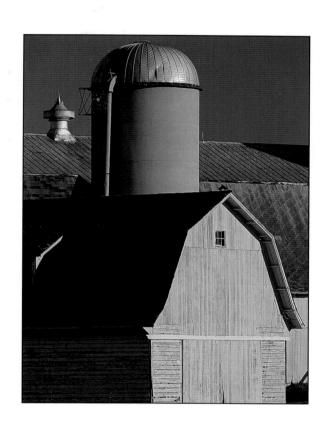

The Barn

Classic Barns of North America

by Nancy Mohr

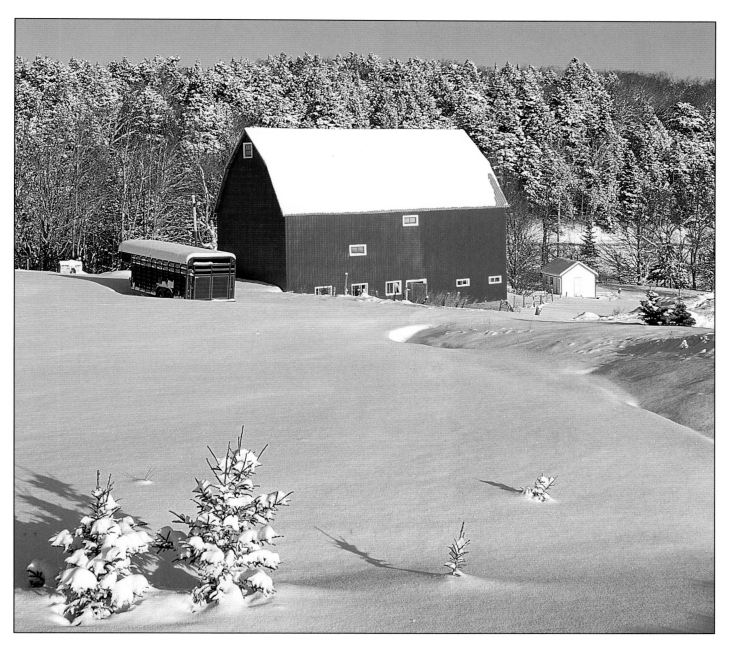

COURAGE BOOKS

AN IMPRINT OF RUNNING PRESS
PHILADELPHIA • LONDON

page 1: **A white barn sits beside its silo and showcases distinctive vertical and horizontal planking in Lancaster County, Pennsylvania.**

Front cover: **A classic red barn located near Mount Hood, Oregon.**

Back cover and Front cover detail: **A red barn wall near Putney, Vermont.**

title page: **A traditional red barn located in Nova Scotia, Canada.**

© 2001 by Running Press

Text © 2001 by Nancy L. Mohr

All rights reserved under the Pan-American and International Copyright Conventions

Printed in China

This book may not be reproduced in whole or in part, in any form or by any means, electronic or mechanical, including photocopying, recording, or by any information storage and retrieval system now known or hereafter invented, without written permission from the publisher.

9 8 7 6 5 4 3 2 1

Digit on the right indicates the number of this printing

Library of Congress Cataloging-in-Publication Number 2001087005

ISBN 0-7624-1107-4

Cover and Interior design by Corinda Cook

Edited by Victoria Hyun

Photo research by Jane Sanders

Typography: Galliard and Berkeley

This book may be ordered by mail from the publisher.

But try your bookstore first!

Published by Courage Books, an imprint of

Running Press Book Publishers

125 South Twenty-second Street

Philadelphia, Pennsylvania 19103-4399

Visit us on the web!

www.runningpress.com

Contents

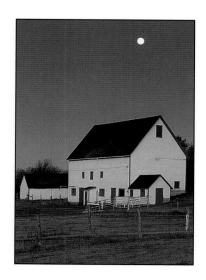

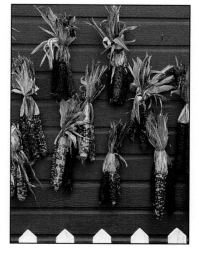

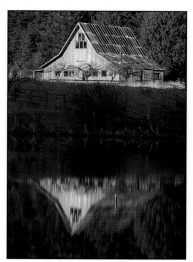

Top: White barn with red trim in Prince Edward Island, Canada.

Center: Indian corn drying on a barn wall near Lancaster, Pennsylvania.

Bottom: Lone barn amidst water and hillside on Orcas Island, Washington.

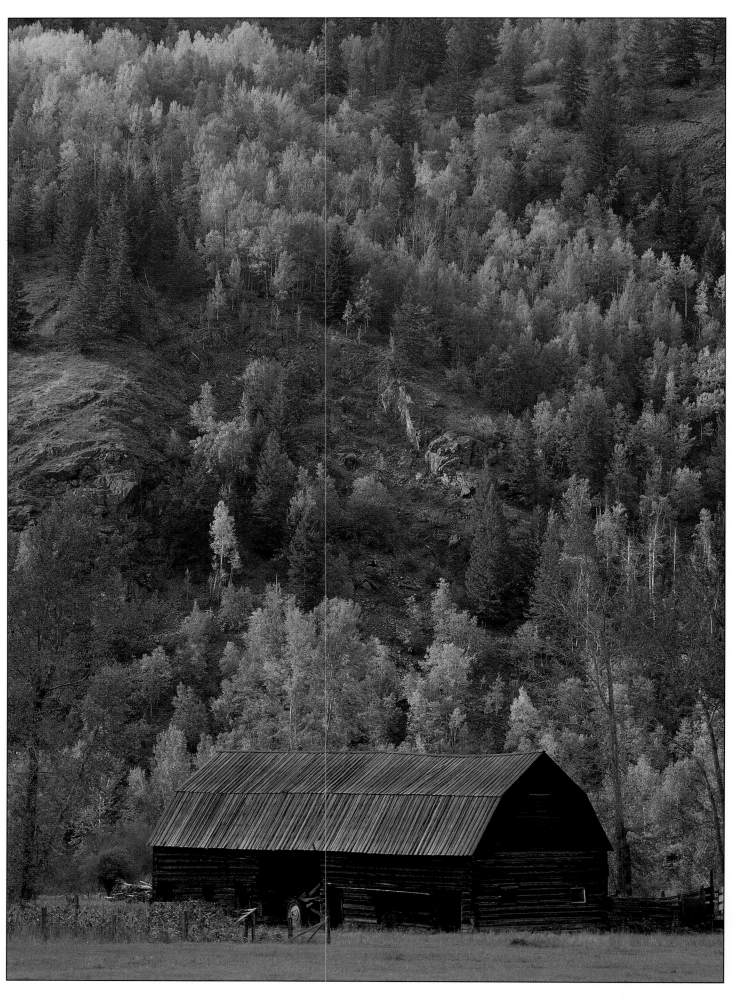

Autumn falls on this classically shaped barn and hillside
in the North Thompson River Valley, British Columbia, Canada.

Introduction

If barns could speak, think of the tales they would tell—of dreams and hardship, success and failure, of lives spent close to the earth where self-sufficiency was the only choice. In the beginning of the twenty-first century, abound with choices, it can be hard to fully comprehend the backbreaking physical effort, never-ending battle with the forces of nature, and the ever-present dangers of striking out into new territory. The ability to build a barn was an important key to survival.

The sense of a barn is tangible, even more so than wandering through an old house and feeling the presence of generations of families. Each successive family changes the appearance of a house, but the buildings that house animals and hay rarely experience substantive changes. I like the way Eric Sloan expresses barn character in his *Age of Barns*: "I pushed open the half-collapsed door and stepped into the blackness. At once, I seemed to have an overwhelming sense of satisfaction and safeness: there was a welcome softness of hay underfoot, and although they could not be seen, the surrounding walls and the oversize beams made themselves felt, almost like something alive there in the darkness. The incense of seasoned wood and the perfume of dry hay mingled to create that distinctive fragrance which only an ancient barn possesses. I felt a strong affinity for the man who built this barn."

Old, still-surviving barns either were well built, or have been well cared for. Weaker, less sturdy structures fell to wind, weather and neglect long ago. Even some of the best barns have disappeared before the inexorable push of bulldozer and development. They were among the original tear downs, the term that addresses the erasing of older dwellings and their replacement, (often) by mega-mansions that will fulfill a far shorter term of service. While the barns of the 18th and 19th centuries were built to endure, a great many new residential structures have a twenty-year life expectancy—they will not be around to record the history of their builders. This has little to do with value: it has everything to do with the pursuit of profit. The handsome, solid barns that linger at the edges of our villages and towns will not be replaced when they are gone. They will be missed by those who knew them. Young people who will grow up without barns in their experience will be deprived, and not even know it.

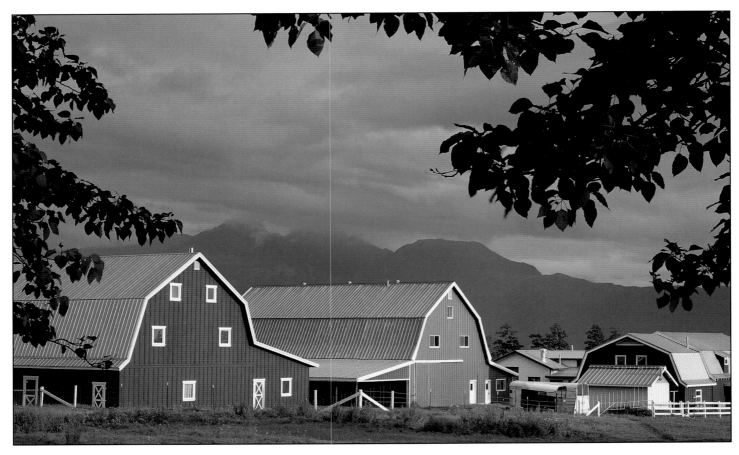

Cottonwood boughs frame these lovely barns in the Matanuska Valley, near the Wasilla Alaska and Chugach Mountains.

Few buildings look more forlorn than a barn about to collapse: sagging roof, doors hanging from rusty hinges, abandoned, unloved. In Pennsylvania's Lancaster County, just off I-283, the side of a handsome but decaying Victorian barn long displayed a large sign soliciting funds for its preservation, even as the surrounding fields grew development houses instead of crops. After years of looking ever sadder, it was suddenly blessed with a new coat of white paint, and the shutters were re-hung. It is probably the closest most of the commuters who zoom by it every day will ever come to knowing a barn.

Fast food chains and family restaurants have adopted elements of barn design. Barn dances are popular in gyms. Children's drawings of farms always include barns, but the same children often are unaware of the fact that potatoes and carrots grow underground, not on top, and have no idea how far the fruits and vegetables they eat off-season must travel. Home buyers are attracted by houses near picturesque farms, and then immediately complain of the smells of manure spreading or the noise and lights of tractors as farmers race to get their hay in before a rainstorm.

With the arrival of the automobile, the broad sides of barns attracted advertising signs, one of the most common being for Red Pouch Tobacco. Then there were the Burma Shave rhymes on little signs that marched along the edge of cornfields and pasture north, south, east and west. A faded message on a red barn south of Lexington, Virginia still reads "Leech Herefords." The adjacent lane leads to the top of a hill and a small country church and graveyard where generations of the Leech family are buried. More people know the name from seeing it on the barn than have ever searched out the rows of stones that mark the passing of generations of the farming family.

Well into the latter half of the twentieth century, it was possible to know barns without living out in the country. They were still visible in the small towns and suburbs as vestiges of the decades when prosperous families maintained horses and carriages. Automobiles displaced the horses, but barns often took on second lives as garages and wonderful places for children to play, especially on rainy days. The child whose back yard boasted a barn enjoyed a step up in popularity.

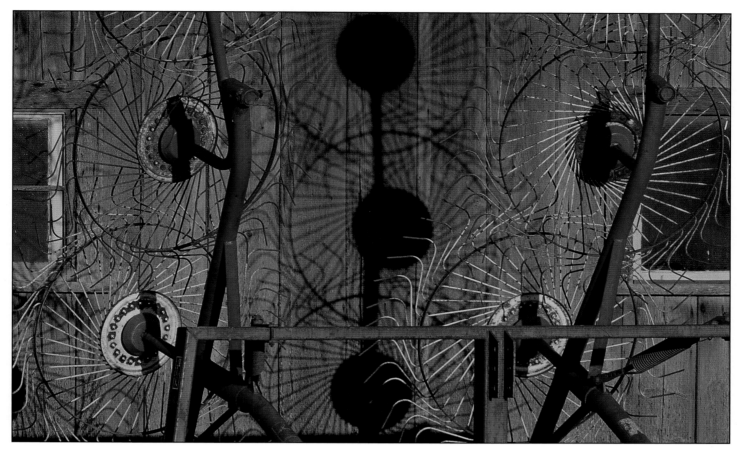

Shadow play on a barn wall located
in Skagit Valley, Washington.

In fifth grade, my friends and I had our "barn." Not ours to be sure, but one that adults seemed to have forgotten. Walking home from school, we often stopped to explore the fine old barn with its great heavy beams, sunlight streaming through the loft doors, piles of fragrant hay—probably not the safest place, but we did love it. The nearby house was a wreck, far too dilapidated to consider entering. The pastures and fields were overgrown, and no one seemed interested in the barn except us. Then one spring, we slipped through the woods to start a new season and all that remained was a muddy, scraped clearing. The barn, our barn, had vanished without a trace. Not a sign that either the barn or house had ever existed. We felt we'd lost a friend.

One summer, my parents rented a house on a lake in New Hampshire. The larger part of the property was still a working farm with a large red dairy barn. I lost little time in striking up a friendship with Mr. McNeil, the resident farmer. He taught me how to milk cows early on summer mornings when my parents and little sisters were fast asleep. It was my special time. I gathered memories of the warmth of leaning against a cow and the ping-ping-ping of milk hitting the pail, and sneezed as I forked hay into the mangers. I was allergic to both milk and dust, but sneezes were small payment for the pleasure I found there.

Our own children grew up in the country, blessed with a father who was willing to trade long commuting hours for the connection between the good earth and personal growth. They knew that animals must be fed and watered no matter how tired you might be, or how unpleasant the journey to the barn may be in cold, rain and snow. The rewards were long rides on fat ponies across beautiful rolling country to meet a friend who came half the distance. Then, perhaps, the child and pony had a sleepover at the friend's house. The deep woods were for exploring, building huts and searching for arrowheads. Between the demands of school and activities, time has always been reserved for raising cattle, pigs, chickens, geese and ducks, for cleaning out stalls, brushing horses and ponies, loading and unloading hay—and most of that activity was centered in the barn. The boys worked for a farmer during high school summers, up at dawn and ready for a shower and bed after dark, tossing

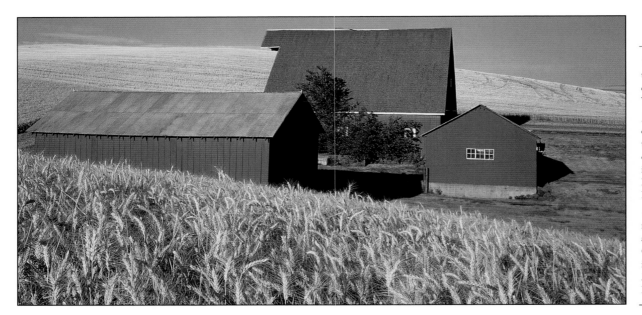

Top: **A glimpse of the Palouse wheat country in eastern Washington.**

Bottom: **Evidence of use: A horse tie-ring and horse-chewed shingles in Stanley Bridge, Prince Edward Island, Canada.**

Opposite page: **A restored barn houses an old carriage in Cades Cove, located in Great Smoky Mountains National Park, Tennessee.**

countless bales of hay, learning to drive tractors and trucks and probably being fitter than most of their friends when the fall soccer season started. They experienced a happy growing time with one foot firmly planted in a farming community and the other in the faster-paced final quarter of the twentieth century.

At the beginning of that quarter, they not only knew about working in a barn, they began living in one. Our original small farm was being surrounded by a new

golf course, which was hardly compatible with our animals and their occasional independent forays. We stumbled onto a splendid property which overlooked Green Valley, a quiet place dotted with both preserved and crumbling relics of the 18th and 19th centuries. A lovely stone barn belonging to the family of our youngest son's best friend is easily one of the most photographed barns, not only in Chester County, but perhaps in all the United States. In researching this book, I came across it again and again in both American and Canadian publications.

As we planned for this new land, once part of a larger farm, we yearned for a new "old house" that mirrored the age and atmosphere of our old farmhouse. With seven of us to shelter, the house had to be sizable. In a moment of sheer inspiration, John suggested taking our largest barn with us—certainly a better future for it than a party house for the golf operation or for a dinner theater that had been waving offers at us. Remember that this was long before the idea of dismantling barns had popularity with any but the Amish.

We searched out an Amish crew to take the big double decker barn apart, peg by peg, save the majority of the roofing slate and help us recycle the materials into a house that reflected the original layout. The project deserves a book in itself, for all that we learned about the mechanics of barn building. Our barn-house was set into a bank (Pennsylvania), with a sheltering courtyard (Swiss), and house, working barn and garage connected (New England) so that we intruded upon the landscape as little as possible. We would be able to care for the animals in the worst of weather without leaving shelter, even feeding them in pajamas and bathrobes on a Sunday morning.

Throughout the last twenty-six years in this 1867 barn, we have always felt the presence of those who came before—from the Roman numerals that keyed one beam or column to another, to carved initials and dates on beams, from stairs worn by a hundred years of footsteps, to old slates that chatter in the wind. Friends and strangers alike respond to the warmth and welcome of this remade-handmade house that we hope future generations will want to preserve. It would be devastating to imagine that such a wonderful barn and dwelling place might ever become a tear down.

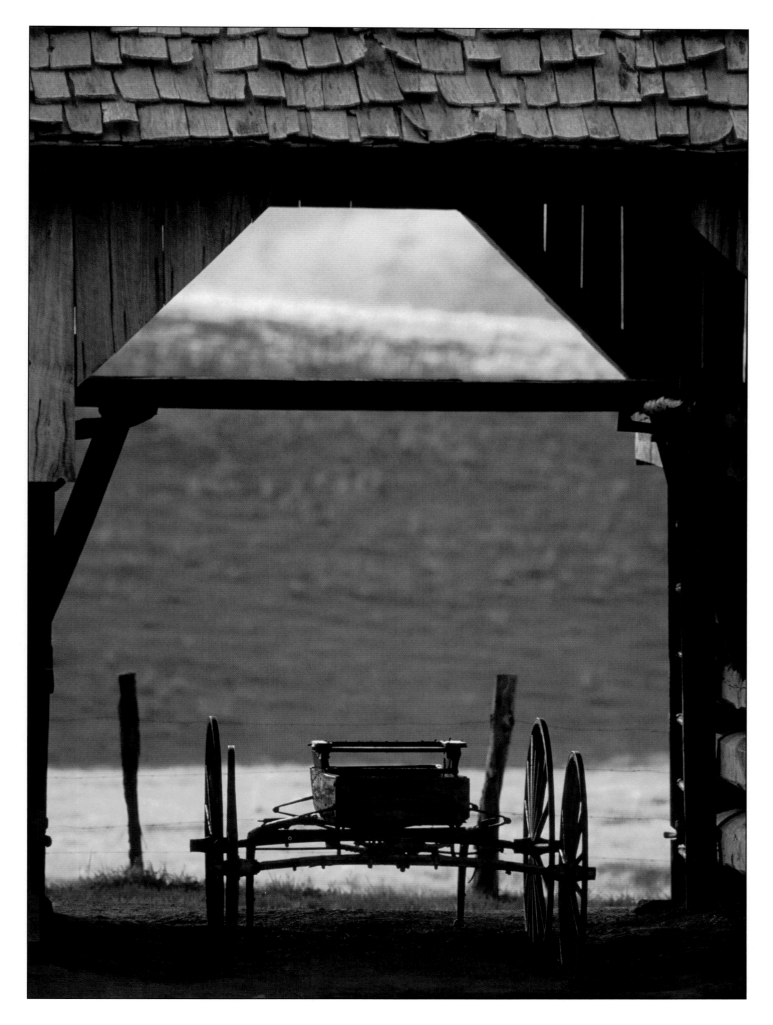

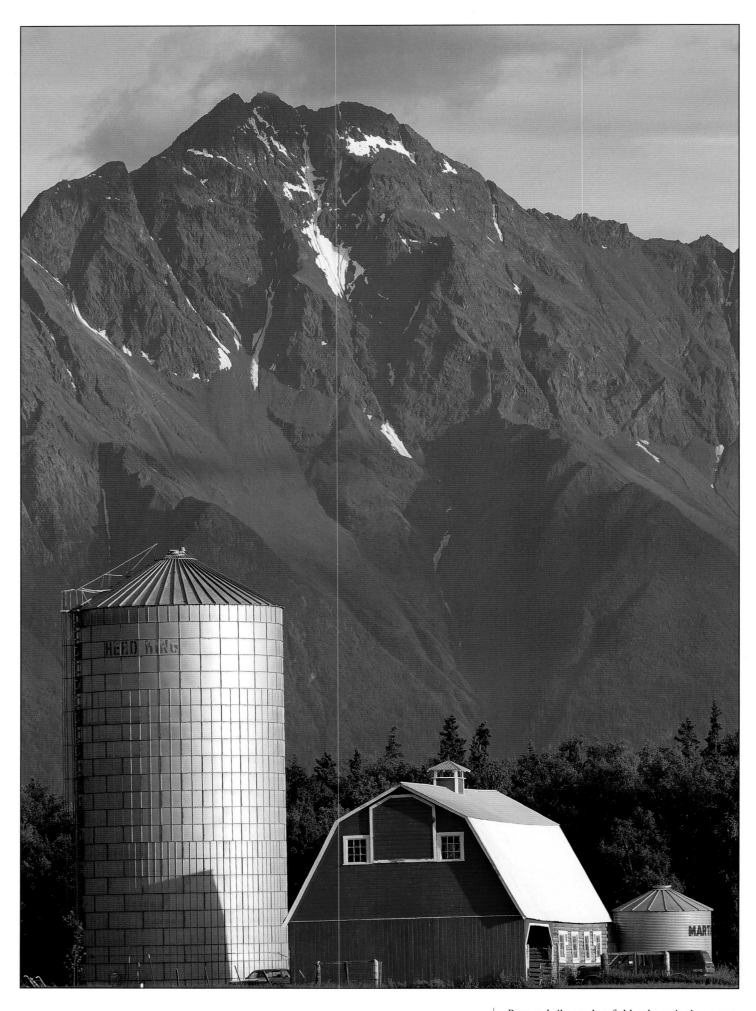

Barn and silo are dwarfed by the majestic presence of Pioneer Peak near Palmer, Alaska.

What Is a Barn?

A barn is a barn is a barn, only it isn't. Barns are as individual as their owners, in purpose and design. An early 1700s definition speaks of a barn as, "a kind of house wherein grain is put," and even earlier, "a place for laying up any sort of grain, hay or straw." Finally, "a farm building for housing produce, implements, or livestock." That doesn't begin to tell the story. Most simply, an old barn is an honest expression of the way a farmer and his family lived their lives.

For centuries, farmers created barns from memory and experience, using the materials most readily available. They used whatever skills they had learned, considered the uses to which the barn would be put, remembered perfectly and imperfectly barns they had known, and threw themselves into solving problems.

It is fascinating that certain common elements can be found in most barns, regardless of ethnic heritage and geographical distances.

These buildings are deeply rooted in self-sufficiency. They are durable evidence of what a farmer needed to survive. Good farmers had to do everything themselves. There were no artisans for hire. What skills they lacked, they acquired. A farmer read the clouds and the wind and was his own weather forecaster. The family depended upon a partnership with sun and rain to make the most of the land. However, good harvests alone weren't enough without a barn to store the grains and hay and to provide shelter for animals. Historically, farming has been a twenty-four-hour-a-day way of life. Farmers, hardworking and rarely possessed of anything resembling wealth, deserve respect for their perseverance.

There is more romance to farming in the eye of the non-farmer than there is in the reality of farming. In 1989, the voters in Chester County, Pennsylvania, an area well-known for its handsome barns and passion for preservation, passed a $50 million referendum for the protection of open space and farmland with a resounding 82 percent yes. The majority of that approval came from voters who live in the county's denser areas, the cities and suburbs. The funds sparked a program to purchase development rights from farmers who wanted to stay in farming, generating capital to help them plan for future generations and supporting the county's important agricultural community. Since then, more than 10,000 acres

of prime farmland have been protected for perpetuity. Competition is keen: more than ninety farmers applied for the development rights purchase program in the year 2000.

Where developers once bulldozed barns indiscriminately, a new industry has sprung up around the rescue and cataloging of barns. However, few but the Amish farmers will take one down and then reconstruct it for its original use. Most face a new future as homes.

Well-worn old barns that dot the countryside from east to west have seen it all. They are hand-built relics in a society that has learned to expect automated production of all the elements of building. Need roof trusses? Order them from Home Depot. Can't drive a nail in straight? Get a nail gun. But always remember that the old barns were built to last, and they should be treasured as an intrinsic part of our history.

Top: A red barn watches over a country road with characteristically steep roof slopes northwest of Manheim, Pennsylvania.
Bottom: Beautifully maintained white barns admire the sunset in Lincoln, Pennsylvania.

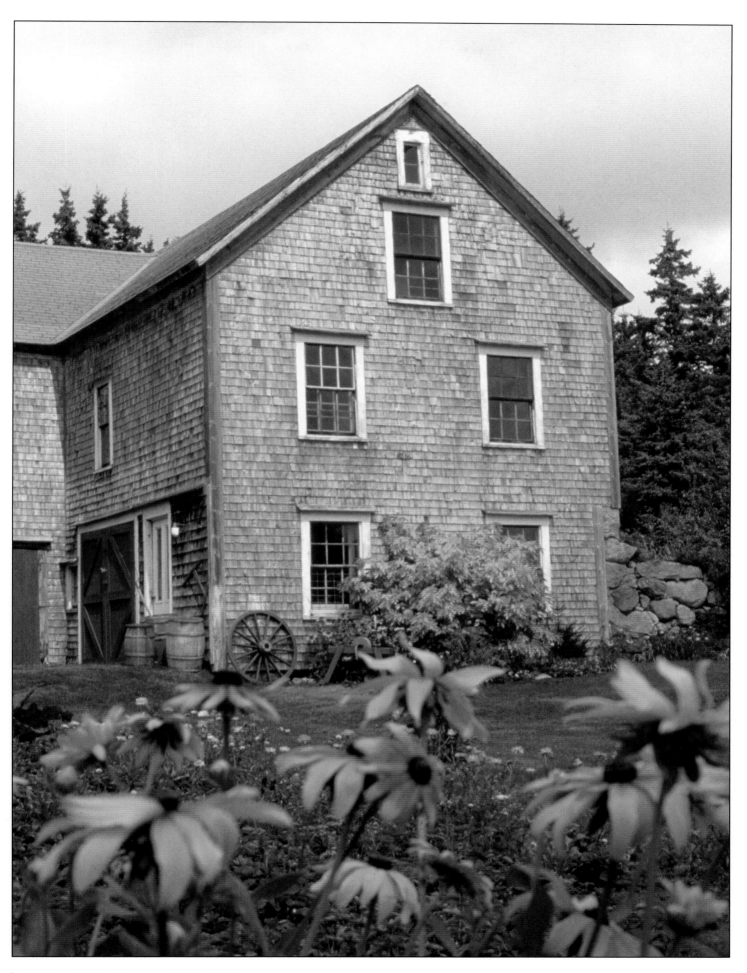

Golden rudbeckias bloom outside this oilskin barn
in Barrington, Nova Scotia, Canada.

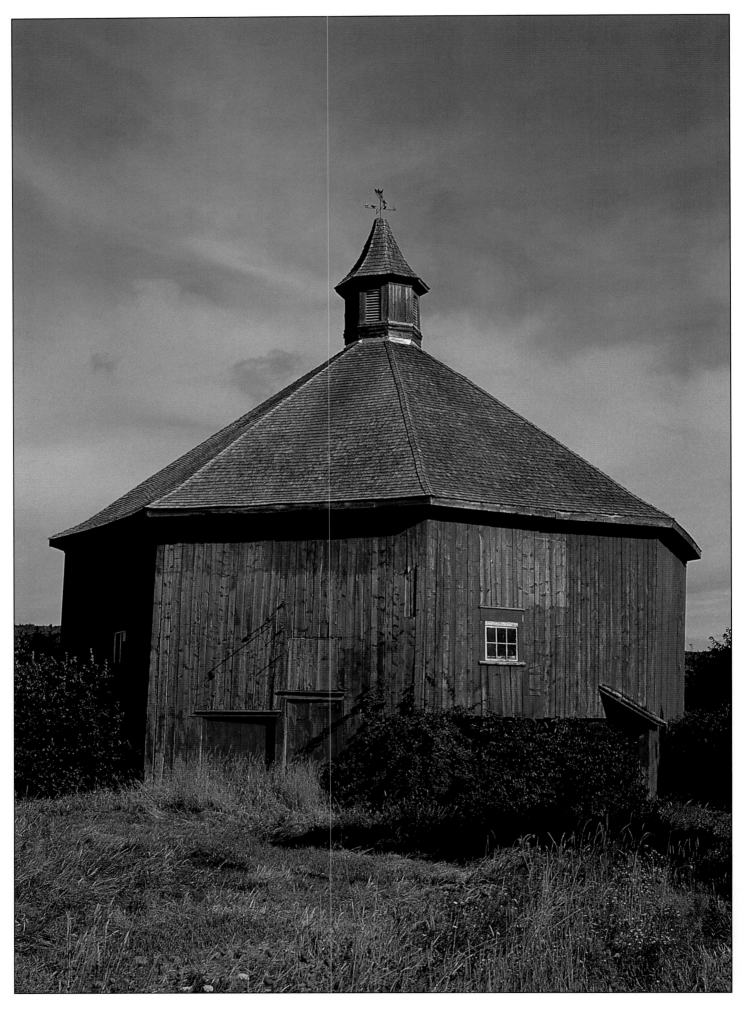

A hexagonal barn in Annapolis Royal, Nova Scotia, Canada.

Medieval Roots

The soaring spaces of a large barn have been compared to those of the medieval cathedrals that took hundreds of years and many generations of artisans to build. Barns are built of less durable materials and have heavier wear and tear. They are nearly empty in the summer when the previous season's harvest has been consumed and animals are out at pasture, but eventually they're filled again with hay and grain to nourish both humans and animals. The structure of an old barn guards a certain spirituality, a close connection to nature in its seasonal renewal. Poor harvests translate into sad, partially filled barns, providing little assurance of sustenance for the long winter ahead. A full barn, on the other hand, creates a sense of comfort, the knowledge that no one will go hungry.

The oldest barns, primarily those in Europe, date to medieval times when wealth, expressed in harvests of grain, was controlled by the church, which built vast storehouses for its harvests. During the centuries before the discovery and colonization of North America, barn building skills and traditions developed in relative isolation. In central and northern Europe, the Germans, Finns, and Swedes built their barns of logs. Severe winters demanded thick walls, and a plentiful supply of trees fulfilled the need. In England, builders used large timbers for the framework, then filled the spaces between with rubble stone and mud (hence the term half-timbered).

A barn's purpose was dictated by climate. Barns in relatively mild England were intended for grain storage, while in northern Europe, shelter was necessary for both animals and grain. Under primitive conditions, it was not uncommon for people to share living space with small animals and fowl, relegating cows and pigs to an attached shed.

Barns with direct ties to Europe are still to be found on the North American continent. They may not be exactly as they were in Europe, but the heritage is easy to trace. Notable examples include the following.

The Dutch barn is the most European. It is not Dutch in the sense of duplicating Netherlands barns, and it is different from the barn of the Pennsylvania Germans. The Dutch barn is generally square and compact with a gable entry and huge interior anchor beams. It can be wider than it is long with large wagon

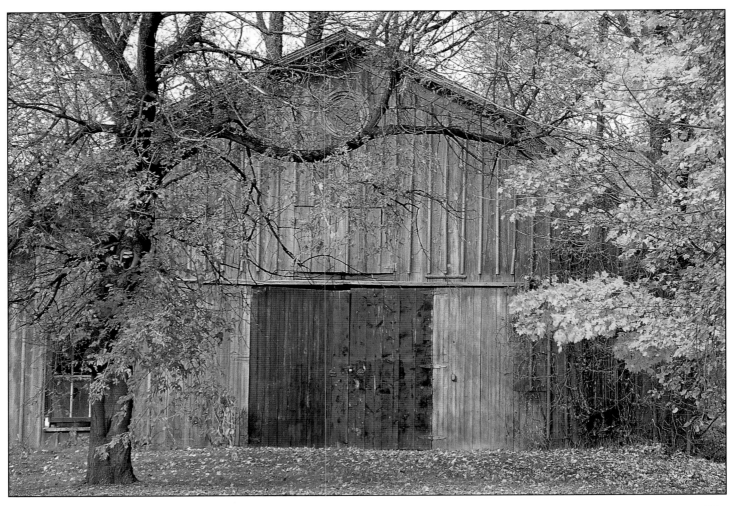

A barn with classic red doors in Ashtabula County, Ohio.

doors. The height of the ridge may be more than twice the height of low sidewalls. The roof projects very little beyond the walls, and, in contrast to most of the other barn types, the siding is horizontal with untapered planks (lapping over one another). Not surprisingly, many of the doors are the familiar, divided Dutch doors. In this type of barn, the tenons are thin, wedged-shaped and then pegged. The very long rafters, as much as 65 feet in length, are heavier at the bottom, designed to balance perfectly before being pinned at the peak. Concentrated in the Dutch settlements, these barns can be found in New York, New Jersey and southeastern Vermont. In south-western Michigan, a Dutch barn might be more

rectangular with a saltbox roof. Painted or unpainted, there may be red doors. The siding may be vertical or board and batten in which case the battens are usually painted white, the boards red.

A *Swedish barn* runs 27 to 28 feet in width and 60 to 62 feet long, a cow barn with hay storage, built of tightly fitted logs or fieldstone. If purely a hay barn, this barn might be a timber frame covered with vertical boards. If there are gable peaks, they usually have vertical siding.

Finnish barns are generally found in northern Wisconsin, northern Minnesota, upper Michigan, and western Ontario. Like the Swedish barn, there is a difference between the barn built for cattle and the one for hay. A cattle barn tends to be

small but tall, with a narrow gambrel roof, a door on the gable end and vertical siding. A hay barn is built of loosely fitted, rounded logs held by saddle notches. The side walls slope slightly inward for rain protection, with some resemblance to a double-crib barn.

A *Czech barn* is confirmation that the area including southeastern South Dakota and the Great Plains states has been home to Czech settlers. The barn measurements average 27 to 30 feet by 48 to 80 feet. The wagon doors are found on the gable end with small main doors to the side. The exterior walls are often plastered and whitewashed fieldstone.

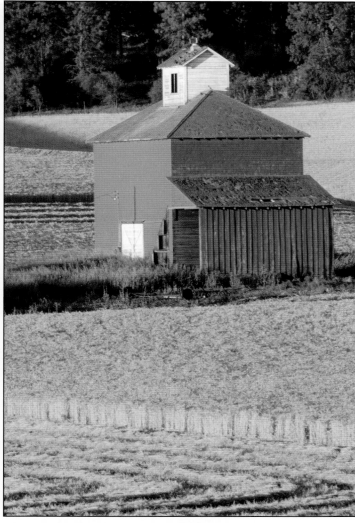

Above left: Barn beams and hay, Stanhope, Quebec, Canada.

Above right: A picturesque red barn among harvested pea and wheat fields near Kamiak Butte, Eastern Washington.

Bottom: Weathered barn amongst autumn foliage west of Shadow Lake, Vermont.

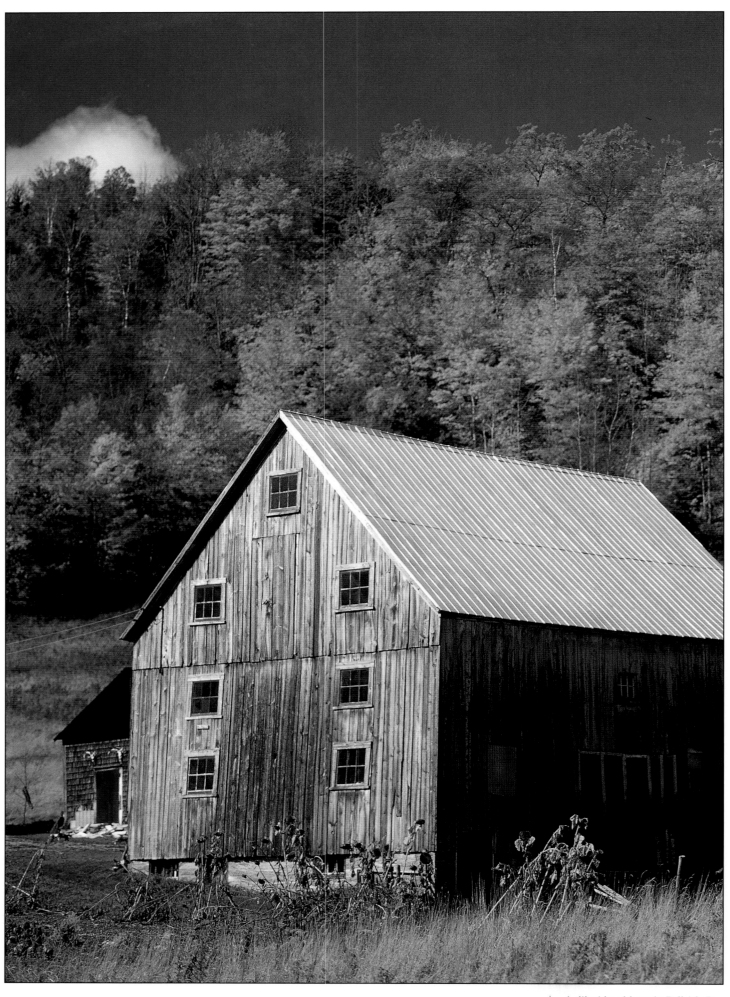

A dilapidated barn in Belleisle Bay, New Brunswick, Canada.

CHAPTER 3

Our Barns Came from Everywhere

Across the vast spaces of the United States, the heartland is often marked by the lonely silhouettes of abandoned barns. Weathered siding, dilapidated sheds, a weathervane dimpled with birdshot, a tired silo, and faded decorations hint of once vital centers of activity. In referring to the barns of early Americans, writer Eric Sloan comments that, ". . . too often their barns are regarded as mere curiosities. They are, rather, the shrines of a good life and ought to be remembered."

How often do we exclaim, "Oh, look at that beautiful barn," or "Isn't it sad that barn has gone to rack and ruin," expressing opinions that are in context with the somewhat romantic value our society places on farming, but isolated from the history that produced them. For

instance, the crisp look in New England of red or weathered barns against the snow belies the fact that the siding is rarely weather proof. Vertical plank siding is the tradition there, even though you can almost feel the snow sifting through the cracks between the boards. The overwhelming domination of wood barns in the northeast is surprising in light of the seemingly endless supply of stone, that even in modern times, seems to rise with each spring plowing.

Substantial differences are found in the evolution of individual barn designs. Although ethnic heritage may be responsible for design, the availability of raw materials dictated the final structure. As settlers in Pennsylvania cut down trees and pulled and burned stumps to clear crop land, there was a ready supply of logs

for houses and barns. Many early homes were little better than the shelters the farmers built for their stock, justifiable in the reality that without the oxen or draft horses, cows and pigs, the settlers would not have made it through the first winter.

It is interesting to note that at the end of the 1700s, there were some 9,000 taxable log barns in Pennsylvania and less than 2,000 stone barns. During the Revolutionary period the estimate is that half of all American barns were built of logs. Stone barns required special skills and tools, while nearly any strong-backed couple might build a modest log barn. And even in that early time, the tax assessor was out checking up on who had built what and where.

Farther south, in western Maryland, West Virginia, and Kentucky, mountain

barns were simple corn cribs, while stacks of hay were often sheltered under the partial cover of a thatched roof set on posts. Many of these barns were initially log dwellings, used as corn cribs after a family built a new home that probably was a larger, more weather-proof crib. The survivors of these early barns retain their personality through the lingering smell of horses and cows, hay, old wood still the preserve of swooping barn swallows, perhaps a persistent owl and barn cat. A vintage tractor may rust in the corner,

draped with cobwebs, keeping company with old hand tools and a hay rake. Snow blows under the door in winter, and in warm weather the rain pounds noisily on the leaky tin roof.

Considering the minimal tools available, native materials translated into nearly monumental structures. Farmers interpreted what they knew of other barns to build whatever suited their needs. Only in the pages of novels do these efforts become romantic. At the same time that a settler, his wife, and

children (usually) raced the calendar to be under roof in time for cold weather, they had to keep the animals fed, milk the cows and clear the land. It was exhausting work, done regardless of hot or cold, windy or wet weather. A full hay loft was crucial to the animals nourishment over the long winter, and no crop was more vulnerable to the vagaries of nature. Hay cut and then rained on for a couple of days before getting under shelter was worthless.

Two hundred years ago, barns were

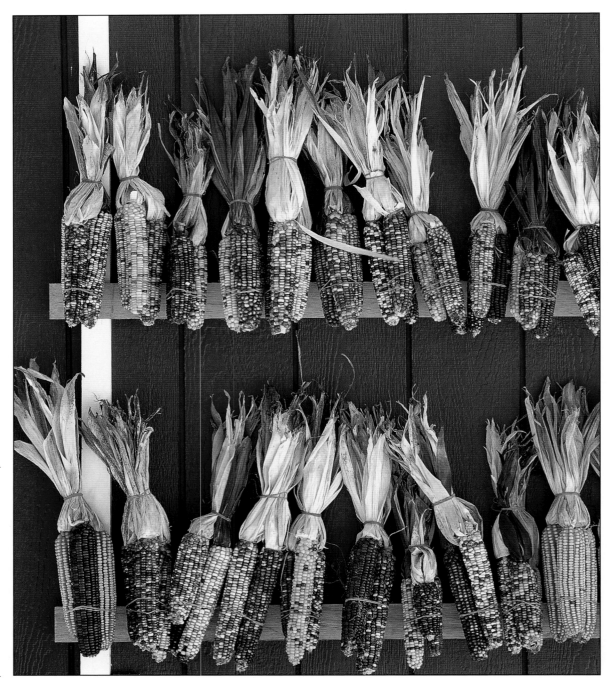

Left: A colorful array of indian corn hangs along a barn wall near Lancaster, Pennsylvania.

Right: This beautiful red barn is located in Amqui, Quebec, Canada.

Overleaf: This impressive round barn was built in 1862, rebuilt again in 1864, then restored in 1968, located in Hancock Shaker Village, Hancock, Massachusetts.

taken for granted. Little was written about them other than the records for tax assessment. Houses were attention-worthy, especially if they were elegant and architecturally innovative, but the out-buildings rarely engendered comment. Eventually, when the Greek Revival style became popular in the early 1800s, a prosperous farm might have a barn that echoed the lines of the house with which it co-existed. After the Civil War, some farmers might experiment with Victorian touches: elegant cornices, wide barge boards, a fancy cupola for a new barn built of wood, stone, or brick.

Even as recently as fifty years ago, barns didn't attract much attention. Some of the best were already gone, with only a remnant of the heavy stone walls remaining. Then history buffs gradually realized that barns were fascinating repos-itories of cultural information if you paid attention to their whys and wherefores.

Historically, Pennsylvanians played an important role, not only in building the sturdy stone barns that attract tourists and their cameras today, but also in the informal export of design and building techniques across the country. Chester County's good soils and plentiful water attracted families with farming skills from Philadelphia and surrounding communi-ties early in the days when William Penn was making land grants to encourage settlement. An ambitious settler could clear as much as 15 acres a month, at the same time setting aside logs for his house and barn. Material for thatched roofs was available for the taking, although it was

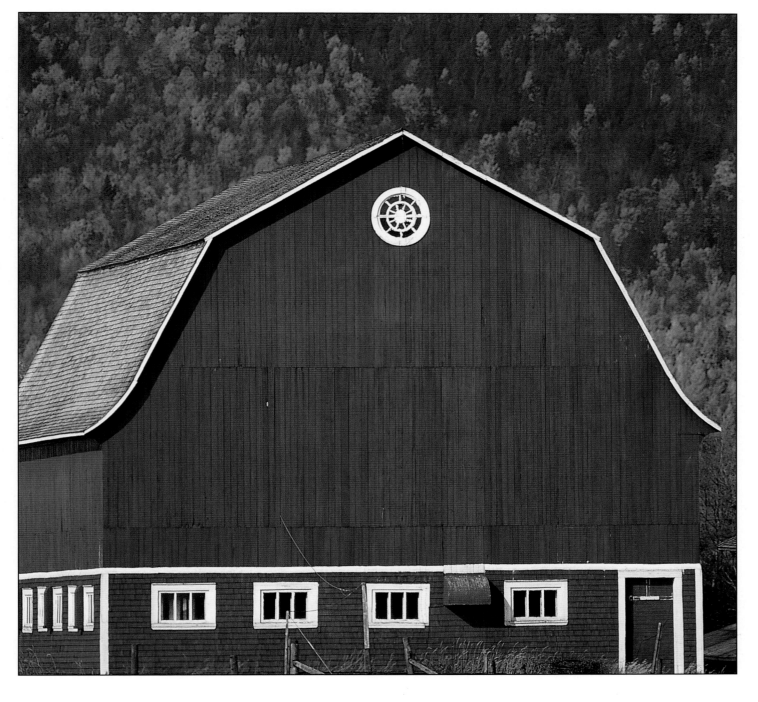

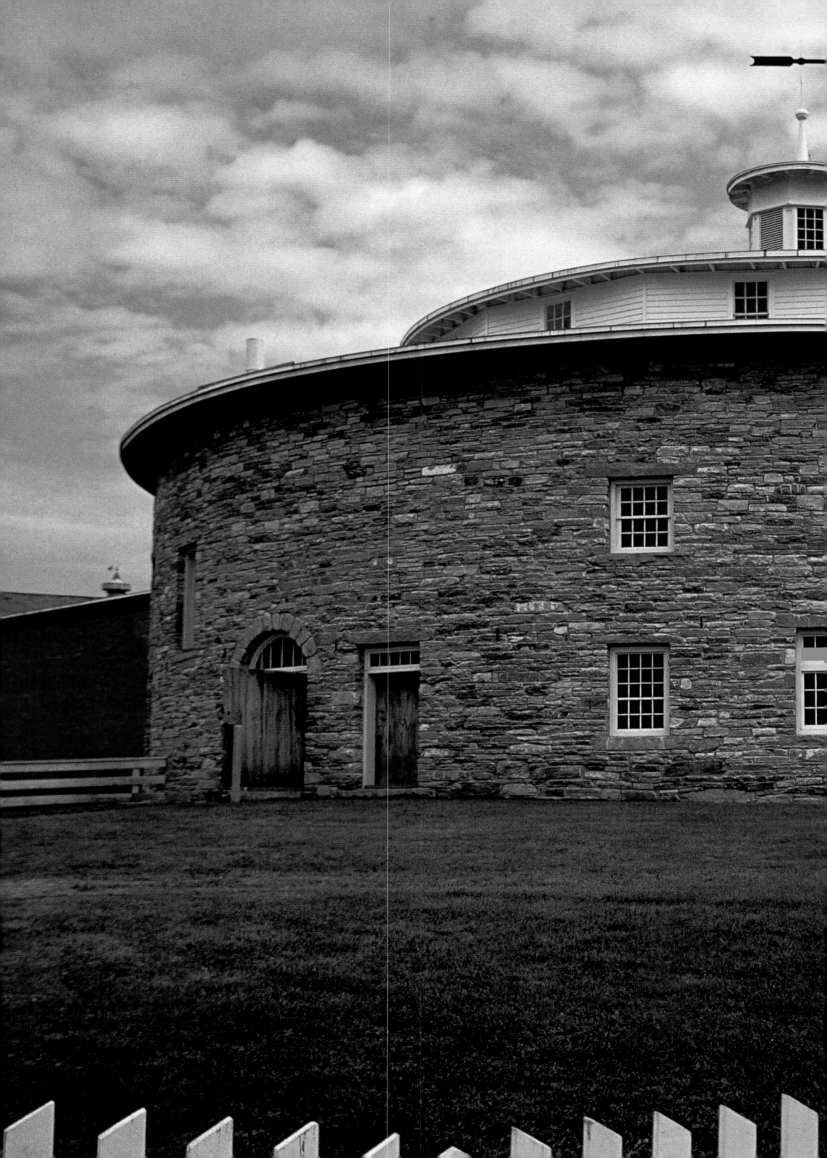

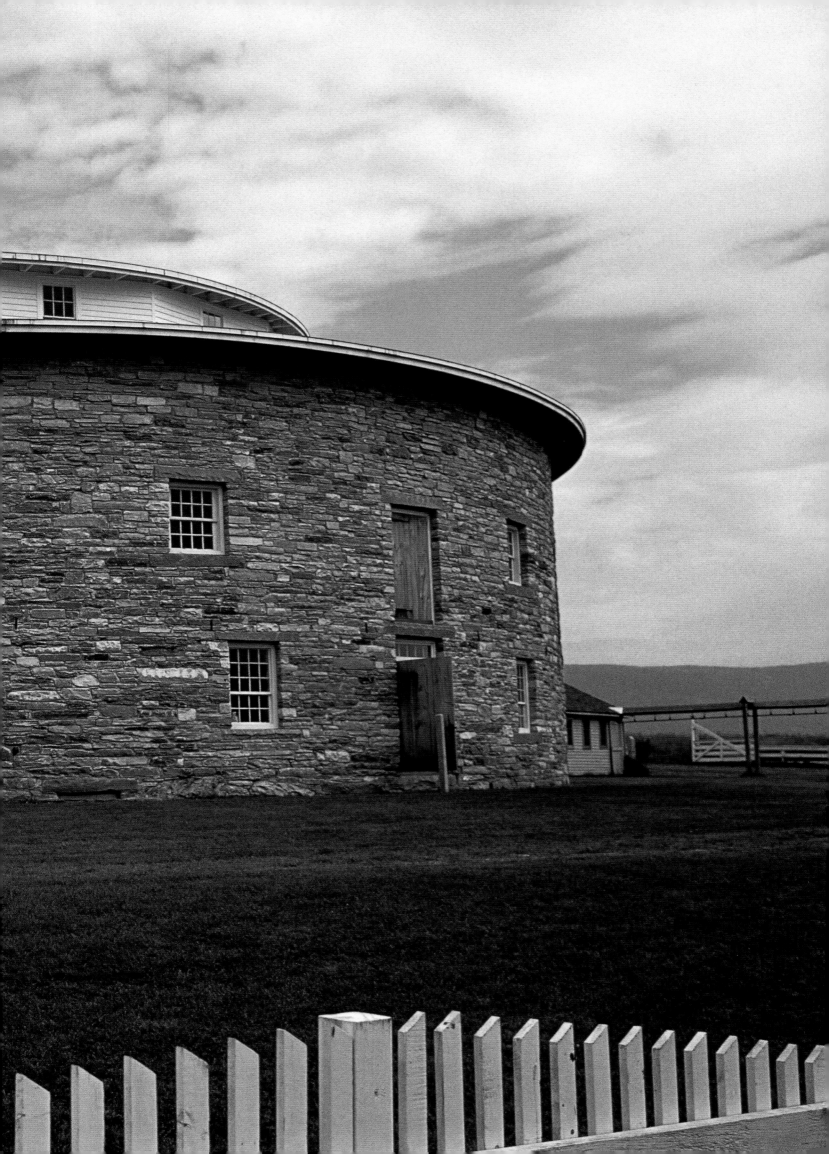

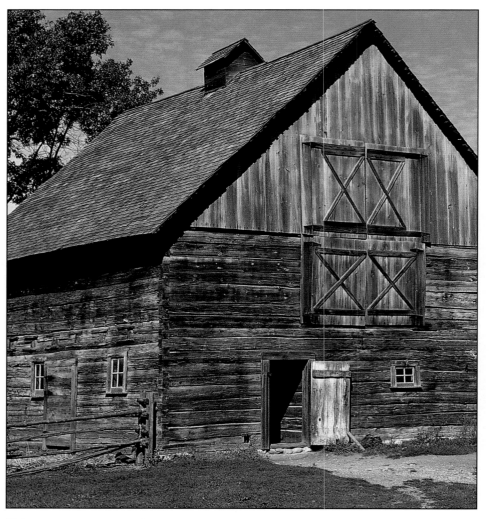

This Kortesmaa Barn was built in 1910 and is located in Eagle, Wisconsin.

The Continental model resulted in a two-level structure, with stabling below, hay and grain above. A cantilevered addition to the upper floor that extended over the barnyard was referred to as an overshoot, foreshoot, or forebay. This tended to be a German contribution that became quite common not only in Pennsylvania but in the states influenced by the Pennsylvania Germans (often mistakenly called Pennsylvania Dutch from Deutsch).

Settlers arrived in North America with little more than their cultural heritage to contribute to the melting pot where old traditions contributed to new ideas and techniques. Newcomers of Swiss ancestry built connected house-barns similar to those they left behind and, except for New England, barns and houses were separated. Combinations of European designs resulted in barns distinctly American and original.

Barns today tell of yesterday's settlements. Eastern Ohio's German bank barns and English raised barns tell that the fertile soils attracted Germans, English, and Scotch-Irish. In southern Wisconsin, the English barns near small communities were built by early settlers who grew wheat while farther from town, large raised barns accommodated later arriving Germans who turned to dairy farming. A mix of cultures was evident in southwestern Iowa where a huge German bank barn was surrounded by many farms with Saxon transverse frame barns. It's easy to imagine the arrival in the Midwest of a family from Pennsylvania whose early history derived from Southern Germany, followed by more farmers coming directly from Germany establishing Iowa's large German representation.

highly flammable and soon replaced with shingles or slate. Stone collected from clearing the fields made good, solid foundations and, subsequently, the well-regarded Pennsylvania stone barn appeared. Eventually, most of the early log barns were replaced, either left to decay and crumble or added on to or absorbed within new construction. In the 1990s, in Unionville, an unstable old brick house was torn down and, much to the owner's surprise, there was a well-concealed log house in the very center. They decided to save the log house, and build around it (again). Small and dark, it is more of an artifact than a living space.

It is interesting to note the degree to which the architectural honesty of barns survives changes in housing styles. Barns would come to be "... admired as one of the outstanding vernacular structures in Canada and the Eastern United States" (Alfred Shoemaker, *The Pennsylvania Barn*, 1959). The slope of the roof, proportions of the bays, and location of doors provided clues to the original design influences, while practicality dictated placement on a site. Bank barns always faced south or southeast, set into a hill for weather protection and good drainage. A barn constructed in the English tradition would feature a single floor for hay and grain with, perhaps, later adaptations for horses and cattle.

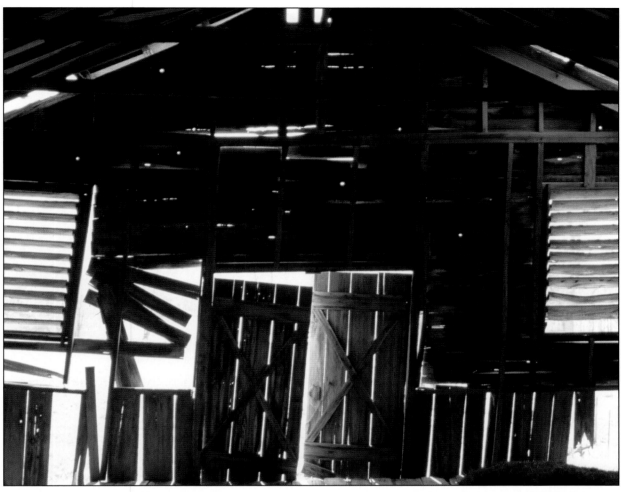

Top: Lights and shadows play in the darkened interior of an old barn loft near Celilia, Louisiana.

Bottom: A typical scene when driving down the highway were the old advertising signs on barn walls. These are located in Macon County, North Carolina in the Tellico Valley.

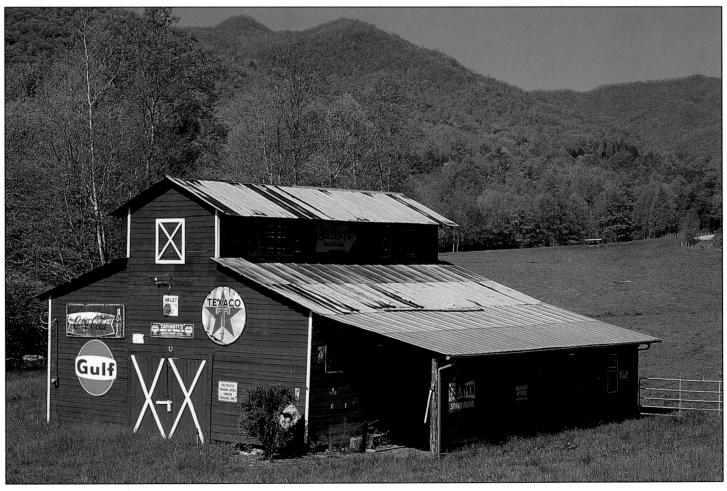

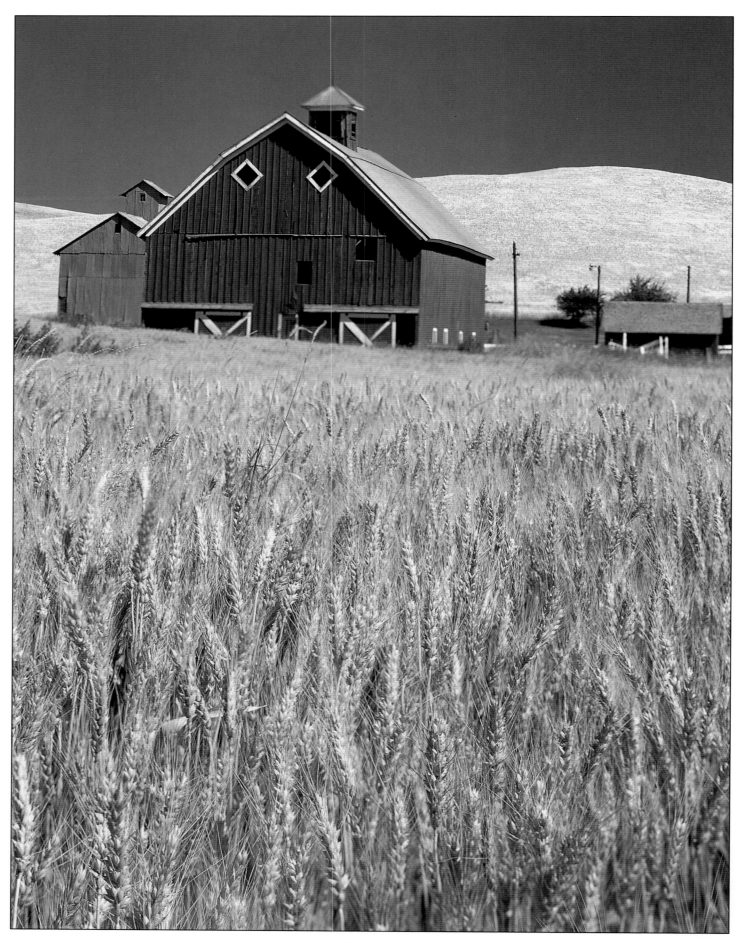

Above: Red barn surrounded by fields of golden wheat in Pine City, Washington.

Right: Details of a weathered barn face.

Small English threshing barns and double-crib barns appeared in upland areas, where only subsistence farming was available to latecomers. Moving toward the Appalachian Plateau, the transverse frame barn that was so appropriate for the Kentucky tobacco farmer disappears, and side-drive and front drive crib barns appear. In the Cumberland Mountains where the land is rugged and there is little prospect for real farming, primitive crib barns filled basic needs. In contrast, the Tennessee River Valley with its gentle slopes and fertile soils encouraged the building of transverse barns, with only a sprinkling of crib barns built by early settlers. The Blue Ridge Mountains, beautiful to look at but characterized by poor farmland, spawned another area of primitive crib barns. The specialty in the Piedmont area of North Carolina proved to be tall, generally square, flue-cured tobacco barns that were usually unpainted. Forge barns were not really barns, but rather places kept warm for repairing tools, with some beginning as a cottage where the family lived while they built the real barn and larger quarters. They appeared without any definite pattern.

Among the wide range of interesting barns, the following seem to be cited most often:

Crib barns were log barns. The weight of the logs kept them in place without internal bracing. The best of these barns were sturdy enough to have lasted, although they may have been covered with wood siding or stone and are not easily recognizable. Few remain in anything close to original condition for

they tended to be temporary, the product of unskilled labor, and were built for a family's immediate survival. A single-crib barn was a box that may have sheltered a settler's family and then been adapted as a barn with the addition of sheds or a lean-to. A variety of configurations could be developed using the single crib as a base, such as two or four stalls separated by one or two aisles, stalls of different dimensions separated by aisles, and any number of sheds. A child playing with Lincoln logs works with essentially the same components that a settler might have had, without the challenge of making the joints fit. The settler's ambitions were limited by his ability with an ax and the strength of

his arms and back. A *crib-derived barn* relates to crib design with universally accepted frame construction. Log pens or cribs were often enclosed by the frame construction if it was an add-on.

A *single crib* would be 8–12 feet on a side, with rough hewn logs that were not chinked, although the loft would often be tightly planked. There might be a lean-to shed on one or both sides. A *cantilevered double-crib barn* was unusual, although one in Cades Cove, Tennessee has been extremely well photographed. Examples where the loft overhangs the crib on all sides still exist in eastern Tennessee, western North Carolina, eastern Kentucky, West Virginia and Virginia.

The *double decker barn* is Pennsylvania in origin and heavily exported elsewhere. It is a three-level barn with a raised threshing floor in the center of the top level, a granary level, and a stable, cow barn, or combination below. A ramp leads to the top level which is floored with thick, heavy (often oak) boards, so that loaded wagons can be driven right into the barn. Occasionally, these floors are pegged for even greater strength and stability. The hay mows run from the granary level to the peak. It is easier to unload grain and hay from above rather than lift from below. Doors in half walls on either side of the threshing floor open to the hay mows, again simplifying the forking of hay from wagon to mow. Even after the baler was invented, the design proved equally useful. On the granary level, three-sided bins had slots along the open side for boards to be slipped in place to raise that side as the bin filled. In some barns, the stairway from the threshing floor was wider than normal corner stairs, presumably to make it possible to carry full bags of grain up or down. Chutes to the stable level provided grain for the cattle and horses. On the rear side of the barn, at the end of one or both hay mows, a distinctive forebay or extension served as a straw shed. If the extension was only a few feet deep, it was cantilevered. If larger, there were posts or tapered stone piers for support. The Pennsylvania barn developed into a totally new expression as German settlers took the old forms and adapted them to their needs. The forebay had an historical relationship with a pent roof for shelter. An observant Englishman, traveling in Chester County in 1806, described a Pennsylvania barn as a gallery, with a six-foot overhang above stable doors. Tall doors in the gallery floor let the farmer throw fodder down from above in the winter. An overhang also serves as a shelter for animals.

In Canada and the United States, throughout New England and upstate New York and across upper Midwest to

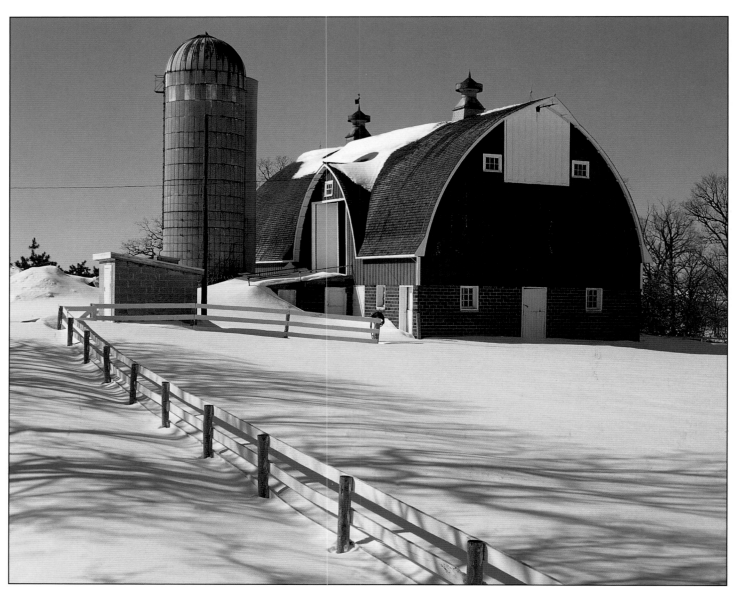

Left: The rounded roof of this Hastings, Minnesota barn sheds the layers of snow.

Top: This distinctive roof feature helps prevent water damage from rain dripping against the barn wood in Parlin, Colorado.

Bottom: Cloverdale Ranch's weathered barn sits through another winter near the town of Sisters in Deschutes County, Oregon.

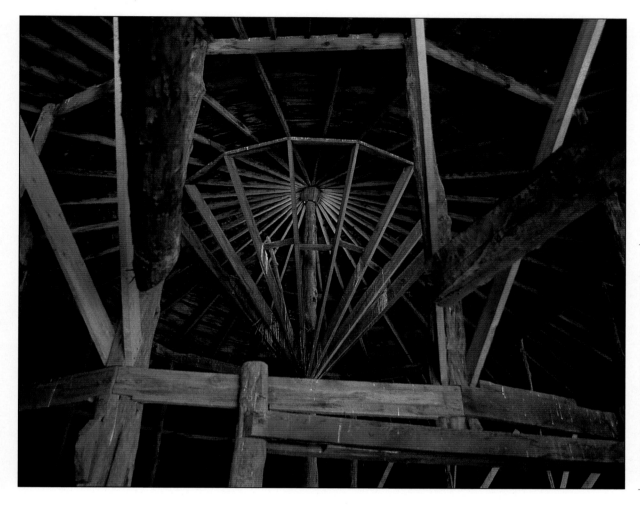

Minnesota, there are many *two-level barns* not double deckers, which have the additional granary level. However, none of these include the distinctive Pennsylvania forebay. There are those who feel that the forebay did not wait for evolution, that it came through prior knowledge of European prototypes, that American barns were not as innovative as we might like to think. The absence of early records of barns in the United States and Canada leaves historians dependent upon fragments of written information and first-hand examination of surviving barns across the continent.

Not as common as the previous examples, each of the following barns described was developed in response to local needs:

The *Appalachian barn* is a full barn with interior aisles. There are no doors in the gable end, except for a large hay loft door.

A *transverse frame barn* places the wagon door in the gable end. There is a centered main aisle, often no loft. Intended primarily for drying tobacco, a row of ventilators along ridge would confirm this use. In the Bluegrass Basin in central Kentucky, the transverse frame barns are often almost black in color, painted with creosote, and adapted for tobacco barns with plenty of ventilation.

The *Midwest three-portal barn* was built with a central aisle and enclosed side aisles. Its early form shows a gable roof, which was often replaced with a gambrel roof.

While the majority of barns were rectangular, occasionally late 19th and early 20th century barn builders took on the challenges of circular or geometric design and construction.

Round barns seemed to be fertile ground for the imagination. There are all sorts of theories about their origin. They are often attributed to religious influences, since farmers are generally considered sober, hardworking, close to nature, and placing high value on a belief in God. Many religious groups came to the colonies to escape persecution or at the least with the hope of fewer restrictions on worship. The Shakers and Quakers each followed distinctive lifestyles. The Shakers were particularly strict and spare in their daily lives, angular in the furniture they made and used. However, they allowed visual relief in their round hats, rugs, and boxes—and also in round barns which legend suggests "kept the devil from hiding in the corners."

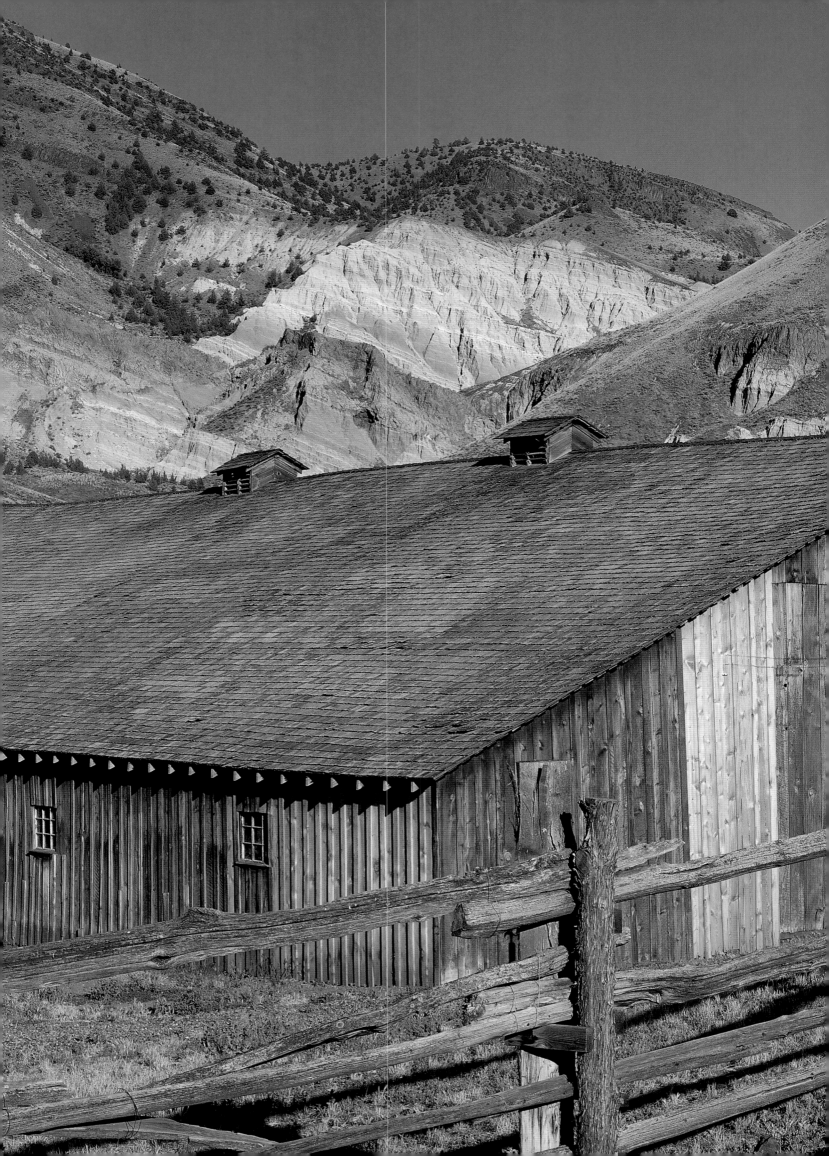

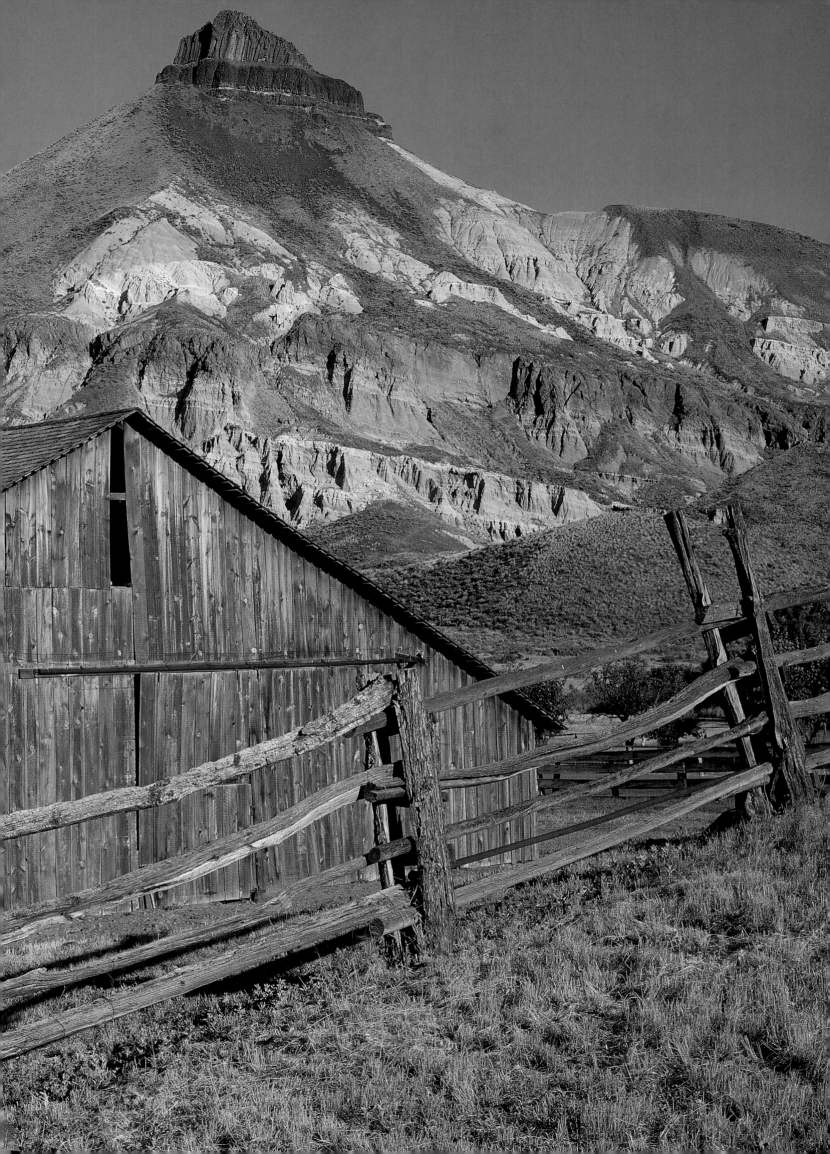

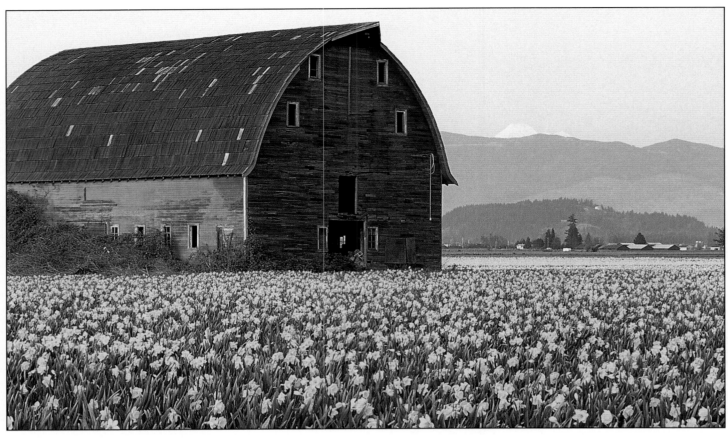

Above: Barn surrounded by daffodils is Skagit Valley, Washington.
Right: Barn, Cap-Egmont, Prince Edward Island, Canada.

A large *round stone barn* in Hanock, Massachusetts deserves mention. Built in 1826, it bears comparison to a fort in its massiveness. Within the walls, there is plenty of room to move around. Two hay wagons can pass each other going in opposite directions. The hay mow is in the center with a ventilator shaft reaching to a cupola on top. Cattle were housed on the ground floor with manure storage underneath. These were certainly rather modern ideas for the early 19th century.

Monumental Barns. The Shakers in New Lebanon, New York cherished a daunting ambition. They wanted to build the biggest of barns, and did so around 1860. 300 feet long and five stories high when it was completed, it had a flat roof. The flat roof was replaced with a gable version when the original proved leaky.

Known as the "North Family Barn," it still stands today. The size is further emphasized by the cupola which is as big as a two-story cottage. The structure is stone with a slate roof.

The *Quebec long barn* is indeed long. A length of 48 to 80 feet is not uncommon. It is similar to the English barn with its side gables and timber framing. There is often an off-center dormer entrance to the loft and flared eaves to deflect water away from the foundation. It is built to withstand the severe winter climate of French Canada.

The *Madawaska twin barn* is actually two identical, parallel, rectangular barns, connected by a low passageway. These barns are found in extreme northern Maine and southern Quebec. Similar barns may be seen in Ohio, but they are

really not twins, rather, two barns built at different times, then connected.

An *Arcadian barn* is rectangular, like the English barn, with a low extension covered by lower pitched roof. The design produces a squarish interior with the area under the higher roof serving as the hay mow. This barn has a threshing floor, granaries, extensions, animal stalls, stables, and a drive-in floor. It is characteristically found in Maine and New Brunswick.

A *Cajun barn* is frame with an 8–12 foot front opening on a gable end. The entry is recessed 6–8 feet into the barn. Stables are set to the side, with a recessed corn crib in the center and hayloft above. These barns are usually about 30 feet square, frequently with side sheds. The original wooden roofing shakes are commonly replaced by tin. As the name might

indicate, these barns can be found in the Cajun areas of Louisiana and extreme eastern Texas.

Hispanic barns tend to be simple. The *tasolera* of northern New Mexico, shelter for livestock and hay, has a gently sloping shed roof. The *tapeista*, in the same area, uses four posts and an elevated platform for piling hay or cornstalks. Later examples may feature a crude open crib of log construction.

A *Hispanic twin-crib* barn is built of horizontal logs with two gable-roofed cribs separated by a covered breezeway. They often began as single cribs.

In a *Manitoba Mennonite housebarn*, the house and barn were originally framed separately. The house was constructed with walls of stacked horizontal 2 x 4s or 2 x 6s. As the design evolved, the two buildings were separated by a connecting shed, and then the house section was turned at a 90 degree angle to the barn.

A *Mormon thatched roof cowshed* consists of a simple structure of 4 to 8 posts with connecting beams and a thatched roof. It can be found in the Rocky Mountains, the Sierra Nevada, and wherever the Mormons established colonies.

Miscellaneous barns. Although large numbers of barns can be traced to ethnic or cultural roots, some farmers built barns to suit specific purposes, with little attention to design. Three-end barns, having the straw shed at right angles to the main barn can be found in eastern Wisconsin. By the end of the 1800s, as the natural supply of local large timber diminished—especially in the prairies and plains—farmers purchased lumber to build their large feeder barns. An *Erie shore barn,* about 30 by 40 feet, was a one story structure with a loft, an off-center side wagon door, and perhaps a side to side runway at the end of the barn. *Pole barns* developed as easy-to-build, not particularly distinguished but highly useful: upright poles, wide gables, low roof pitch, used as loafing barns. It was not unusual to have a wall or two missing. The *polygonal* and *round barns* could have anywhere from 6–14 sides with a ramp to the upper level. They tended to appeal to dairy farmers and were scattered around north and central United States and southern Canada. They generally date from the middle to late 1800s.

The oldest barns were built as early as the 1600s—and those remaining in up-state New York may be the earliest barns built in the United States.

A *silo,* an adjunct to a barn if not really part of one, could be built of either frame or stone. The frame silos are most

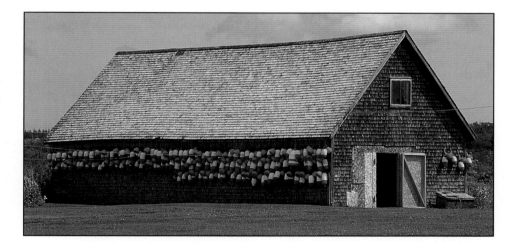

often held together with metal bands or built with more of a square shape than round. An empty round stone silo in a double-decker barn offers a special experience if you are able to look up to the top from the very bottom. They usually run from or slightly below the lowest level of a double decker upward in a meticulous circular pattern of stone. Silos are not as old as the other traditional design elements. Most were added in the late 1800s and early 1900s. They began as cellars or holes in the ground. Even today, farmers dig great trenches in the ground—known as ground silos—to fill with hay for cattle, covering the trench with heavy plastic tarpaulins that are then weighed down with old tires. The first upright silo is said to have been built in 1873 in Illinois. It lacked any supporting framework, being an arrangement of light-weight boards held together with wires and hoops. Apparently the early stone silos were built during a lumber shortage, with Michigan often given credit for building the first one in 1875. Sometimes stone silos were attached to frame barns, a fact which generates the observation that it is odd that there are so few stone buildings in New England where there are so many stones. Many of the early stone silos, however, were in either Michigan or Wisconsin. New England's silos tended to be square and often went as deep into the ground as they were high above the surface. The simply-designed stone and frame silos lasted more than 50 years before the shaped concrete and distinctive blue tile Harvestors appeared.

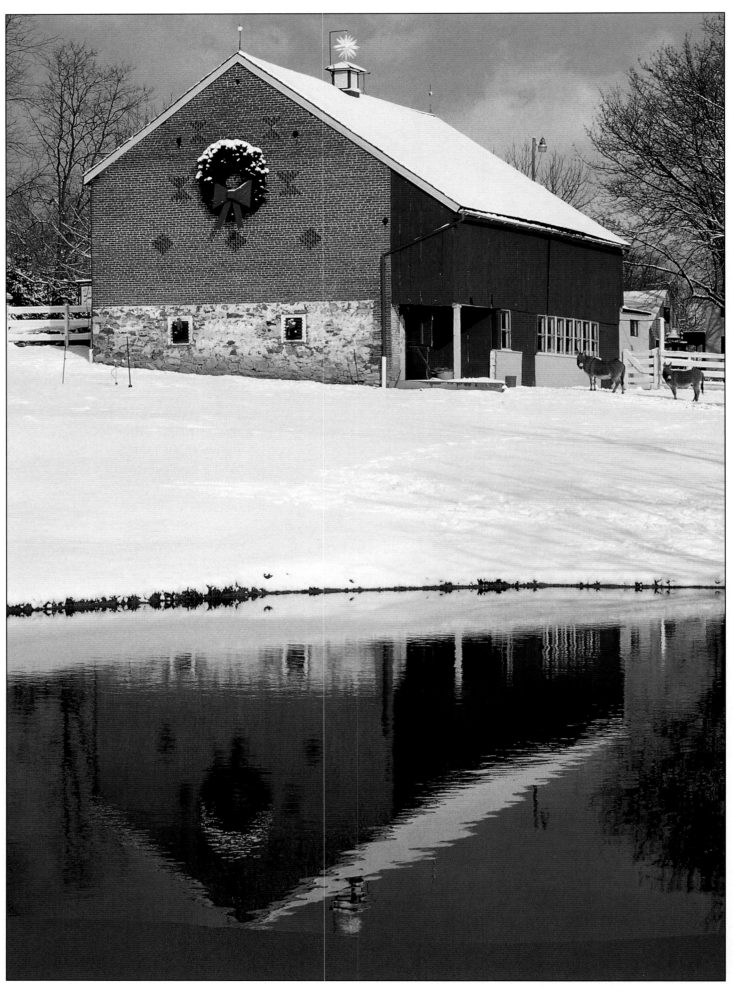

A festively decorated barn in Lititz, Pennsylvania awaits Christmas.

Practicality vs. Beauty: Sometimes Both

Certainly the initial motivation for building barns was purely a matter of practicality. Availability determined the materials, and the builder's skills limited the magnitude or grandeur of the project. Log barns were the easiest to build. Whether a barn preceded a cabin for the settler's family was a decision that probably depended upon the season. If there was a nearby town where a wife and children might be housed temporarily, a farmer might camp on his newly acquired land until he could finish enough of a building to bring the family along. No matter what the circumstances, life in the New World was not easy, even with the limited amenities of England or Europe left far behind.

One of the simple but clear descriptions of what a farmer might consider building is contained in Alfred Shoemaker's 1959 book on barns: "A log barn was a rectangular building, without a foundation or only a simple stone one, and it was one or one and one-half stories high. A log and frame barn were similar except that more boards were employed in the construction of the frame barn than were normally used in erecting a log barn. A log and stone barn was a log structure built upon a substantial flat foundation of stones, or a bank barn with the first story built of stones."

The farmer addressed a long list of considerations. Nails were scarce and costly. Hand-crafted pegs were used in their place. Cut nails were developed in 1809: thus the type of nail is a pretty good clue to the age of any building. A barn took precedence in urgency and quality over the house, for without a solid barn for protection of animals and harvest, the family's existence was threatened. Barn design focused on the useful and practical aspects. Roof slope ran about 40-45 degrees, accommodating the easiest, most available roofing material— rye straw thatch. The roof angle was meant to support rapid draining and drying after rain. A two-section barn would probably have a portion covered with vertical boards to protect grain from moisture and rodents. The spaces between the logs in the hay mow would not be chinked—a matter of keeping air flowing through the hay to guard against spontaneous combustion.

Naturally, the farther the barn builder was from settled areas of the country, the more limited the building

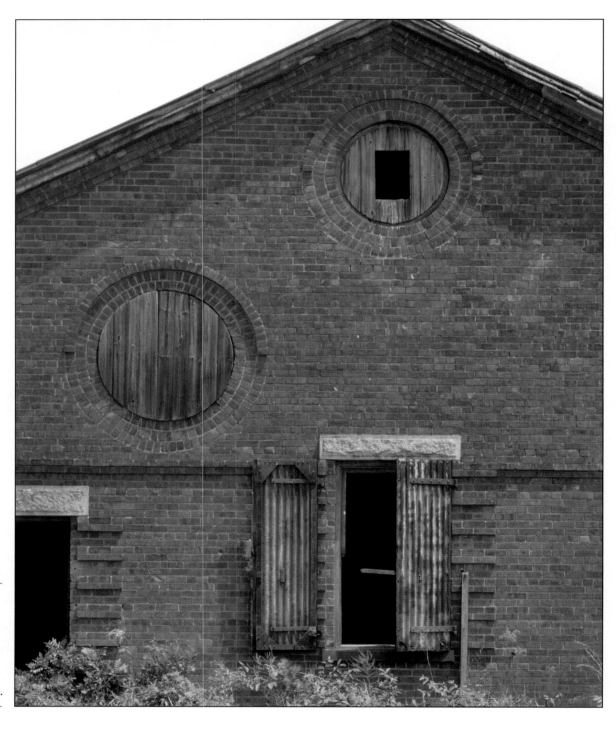

Right: This unusual brick barn sports round windows and is located in Sandy Hook, New Jersey.

Left: An old pioneer barn, Grand Tetons National Park, Wyoming.

techniques. In moving to the mid or far West, a settler carried as much in the way of tools with him as possible. Geography, climate and ethnic preferences dictated form and construction methods. Functional differences centered around potential use—animal housing, storage of crops that were as different as grains, hay, tobacco and potatoes.

In Lancaster and Lebanon counties (Pennsylvania), prosperous farmers built large frame *Swietzer* barns. In Philadelphia and eastern Maryland, the stable level might be stone and the upper stories brick. In New England, for the less affluent areas along the east coast and among the Amish and Mennonites, frame barns were the rule. In Wisconsin, German settlers constructed solid structures by stacking round and split logs, filling in the spaces with lime mortar.

Barns rarely had windows. They were too expensive. When a farmer saved enough money to put windows in his house and had one left over, he might place it high in a barn gable, aligning it with the roof angle so it appeared to be diamond-shaped. Later, if he moved, the windows were carefully removed, packed and taken along to the next farm.

By 1798, Chester County, Pennsylvania's direct tax list showed more log barns than those of any other material,

and it is reasonable to assume that some of the larger, finer barns had swallowed up log structures within their additions. The listing included:

Log barns	6,813
Cabin barns	818
Log & stone	685
Log & frame	43
Stone barns	1,829
Brick	10
Frame	716
Unclassified	4,791

This inventory records the materials of which the barns were built, but fails to indicate the uses. Do they house animals, grain and hay, or do they provide space for craftsmen to work? As farmers learned about crop rotation, fertilizer and improvements in agricultural tools, a new chapter was opening in which farmers would not only farm for subsistence but also for commerce—growing crops for sale to those who didn't farm. Americans leaned toward the combination of many uses in the same barn building, housing animals and storing hay, grain and equipment. Today, no systematic inventory of barns is available. Unfortunately, the barns are rapidly disappearing, and some styles may never be recorded for posterity.

Pioneers showed little inclination for spending more time building barns than absolutely necessary. Rough sheds would do. Except for the Germans who traditionally built barns better than their houses, there was a notable absence of fine barns in the Midwest and West. On the frontier, log houses and barns were prevalent, the best builders being the Scandinavians, Finns, Swiss and south Germans who taught settlers their skills. The settlers, in turn, produced boxes, nothing fancy, but adequate shelter for crops and animals—and people.

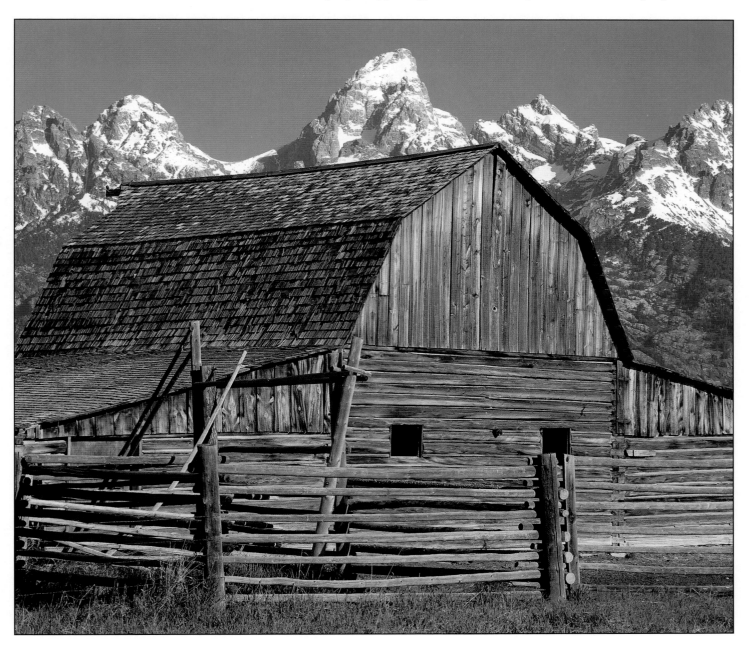

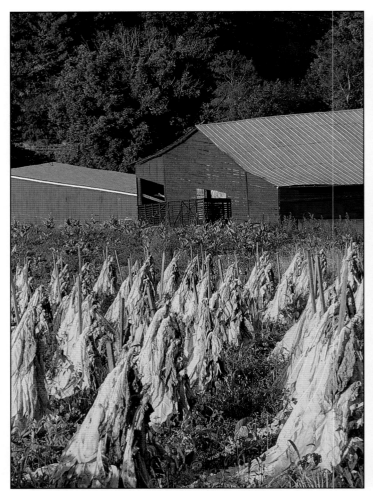

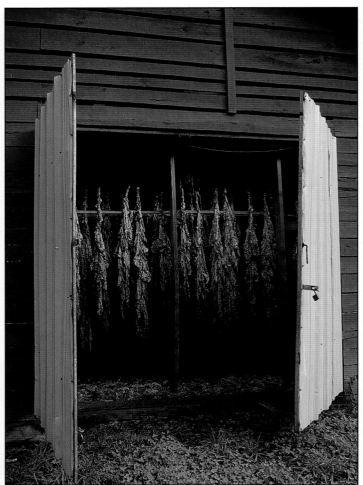

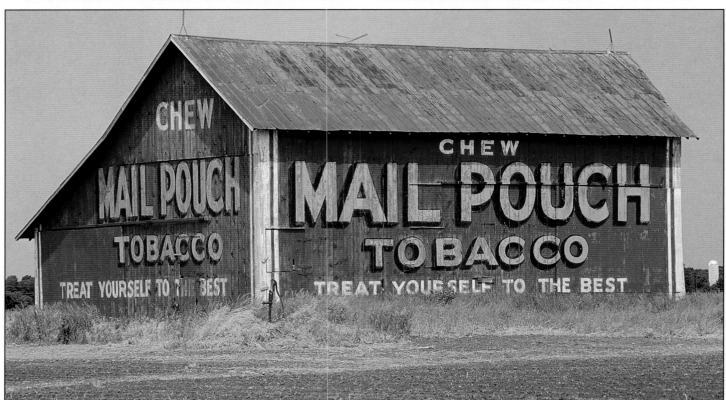

Top right: Tobacco drying in field in front of a red barn in Yancey county, North Carolina.

Top left: Tobacco hanging in a red barn in Swain County, Whittier, North Carolina.

Bottom: Mail Pouch tobacco ad on red barn in Altamont, Illinois.

Opposite page: Old barn with antique advertising signs in Plains, Georgia.

Toward the end of the 19TH century, steam power, the gasoline engine and electricity imposed major changes in farming, its methods and contributions to the economy. By 1900, it was possible to order entire barn packages or plans that provided instruction down to the last nail from a catalog. Timber framing was disappearing except among the Amish. Gable roofs shared the menu with the newer gambrel and Gothic roofs. Barns were no longer a matter of common experience except in the context of their peripheral uses—as work places, dance halls, social centers for bingo, husking bees, and religious services. They had earned a place in the country's history, but became intrinsically less important as the economy and society created more reasons for young people to leave farms and pursue their futures (and fortunes) in the cities. However, barns did and still do retain their importance in the culture for their descriptive value—a barn burner of a speech, barnstorming, can't hit the broad side of a barn, big as a barn door.

Special purpose barns

Remember about need dictating the form of a barn? If you were a dairy farmer, the ideal barn might be 36 x 100 feet or larger with a gambrel or possibly a round roof—perhaps with rows of small windows and gable end doors, roof ventilators, and a drive ramp to the loft. These barns could be found in the dairy belt from New England to Minnesota and a scattering in other areas, too.

If you lived in the northern Rocky Mountains or in British Columbia and wanted a *horse barn,* it would be roughly

28 x 40 feet, made of round and hewn logs with a frame door set in the gable end away from the prevailing wind. Overhead would be a large hay loft, small windows, and gable or gambrel roof.

Carriage houses could be called urban barns for their locations in cities and towns. They are found mostly in the northern half of the United States and southern Canada.

Potato barns looked like no other agricultural buildings for they were half sunken into the ground with sheltering gambrel roofs—perfect for long term, cool storage. They are found in Aroostook County, Maine, central Wisconsin, and Idaho.

Hop barns gained importance in central New York State, southern Wisconsin, California, and Oregon. They were generally built as two-part structures that included a kiln or drying house with an attached processing and storage building.

All *tobacco barns* are similar, with little change over the years, especially in the

Amish country where growing tobacco leaves for cigars is a staple of the economy. Across the country, however, variations reflected tobacco drying preferences. They include:

In Kentucky, Tennessee, and central Virginia, for fire-curing, a barn that is 20–22 x 26–48 feet by 18–20 feet in height with a gable entry.

The North Carolinas show preference for flue curing in a 16–20 feet square barn, over 20 feet high with one or more attached sheds.

In Southern Ontario, Kentucky, Tennessee, south-central Wisconsin, Virginia, and Ohio where air curing is popular, adapted barns show plenty of ventilator panels, vertical or horizontal, and occasionally with clerestories. In Connecticut, tobacco barns appear in pairs that are extremely long and narrow.

Beyond this list, special purpose barns are totally individual in their design and purpose.

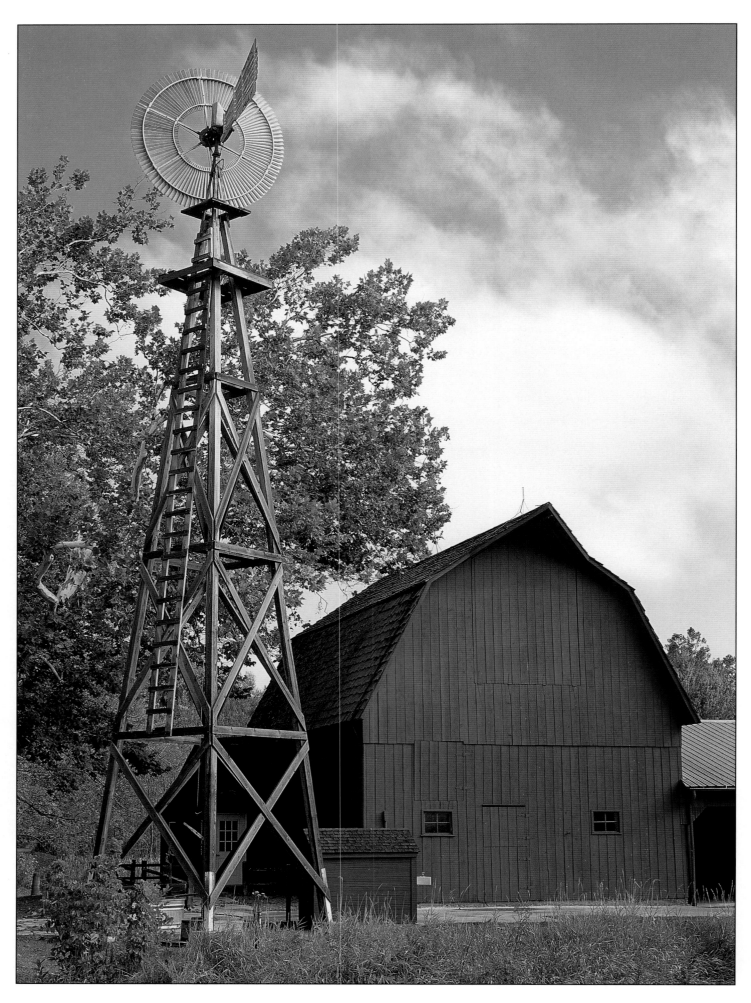

This hay hood roof style barn is coupled with a windmill to make an unusual pair in Bristol, Indiana.

Design

A barn is not just a barn when a farmer settles down to build one. The expression of the practical goal can be totally individual. Every farmer develops a philosophy and methods that (hopefully) contribute to making a farm successful. While a design may draw on ethnic heritage, there are also potential regional and climatic influences.

Although more barns are rectangular than any other shape, there can be reasons to consider a square barn or even one that is polygonal or circular. The less common shapes may be the product of whimsy or religious belief, a fascination with the geometry of structure. As long as the purpose for which it is built is served, why should the shape matter? A Shaker round barn has both the rafters and floorboards radiating from the cen-

ter, the product of the most meticulous planning and carpentry. A Quebec long barn can look simple and unexciting until you go inside and discover an amazing expanse of uninterrupted space and the fascinating pattern of posts and beams. The color of barns is certainly a matter of personal choice. Many barns never see a drop of paint, but red is popular with white coming in second place, dark green in some parts of the country. Decorative touches like hex signs, colored glass balls on lightning rods, weathervanes, advertising signs, folk art (cows, horses) on the sides of barns and intricate designs in the gables of brick barns all offer clues to the man who built the barn or owned it in succeeding generations.

Barn designs changed little from 17th century to the early 20th century.

Searching for the very earliest barn survivors in North America isn't easy. A good sampling of examples from the late 1700s is about the best one can hope for. Survivors tend to have been well built and well cared for until, perhaps, recent years when the number of active farms has diminished. Barns containing elements of original log construction and relatively old frame barns are fairly common in any region where farming has been or still is important. Brick and stone barns required greater investment in materials and labor, and the availability of skilled artisans to prepare and carry out the construction; they are more often found in the Mid-Atlantic states.

Inevitably, the use of certain building materials depended upon a convenient supply, which as far as the stone and brick

barns were concerned was a matter of geology. Limestone was the most common, while sandstone proved more difficult to cut and had limited distribution. Many limestone barns can be found in the "Great Valley" from Pennsylvania's Lehigh Valley south through the Shenandoah Valley in Virginia. The shale rock that weathers to clay is ideal for making bricks, and thus there are brick barns in south central Pennsylvania into northern Maryland, with especially nice brick houses and barns in southeast Chester County, Pennsylvania near the Maryland border.

Additional clues to the geological connection are contained in barn foundations. Gray-blue-whitish foundations were limestone, sandstone was tan or with a yellow tint, bricks indicated the presence of shale rock and in areas influenced by the glaciers, foundations might be granite boulders held together with mortar. It was a matter of practicality that stone and brick were used close to their sources: they were heavy and costly to move.

Once a farmer could make a list of materials, the design exercise was simple and straightforward. A series of basic questions evolved: 1) Shape? 2) How many levels? 3) Access to the second level with a bank or ramp? 4) Bank barn or barn on the flat? 5) Include a forebay? 6) Large wagon doors on the gable or side? 7) Ventilation?

It takes a practiced eye to note differences in barn design and structure. A number of barn designs exhibit some but not all of the same features. Barn aficionados, especially those who enjoy the slower pace of shun-piking off the highways, find rewards in an increased awareness of the ways in which a barn can be different in its representation of cultural and ethnic heritage. Something as seemingly simple as the placement of doors offers a host of choices in terms of historical research. Generally, northeastern and Canadian barns had main doors on a side wall. In the southeastern barns, doors were usually on the gable end. The western United States and Canada

Left: A classic white barn offers a glimpse of Christmas through its barn door in Lancaster, Pennsylvania.

Top: An electric star blazes on the face of a barn wall in Elizabethtown, Pennsylvania.

Bottom: Barn in snow, Cape George, Nova Scotia, Canada.

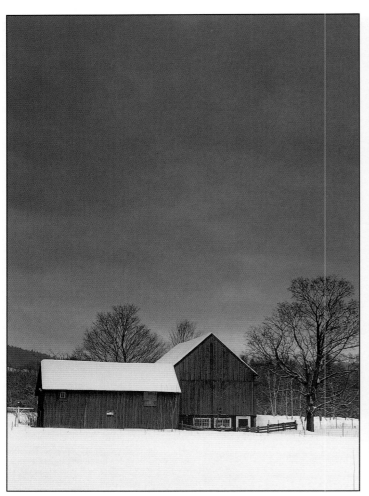

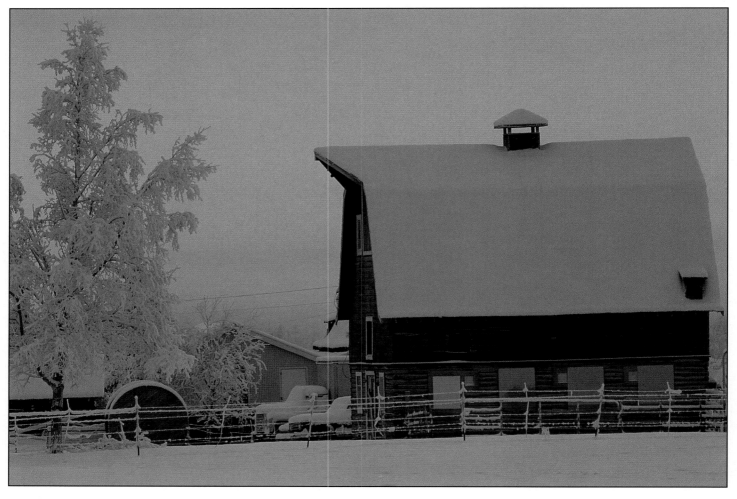

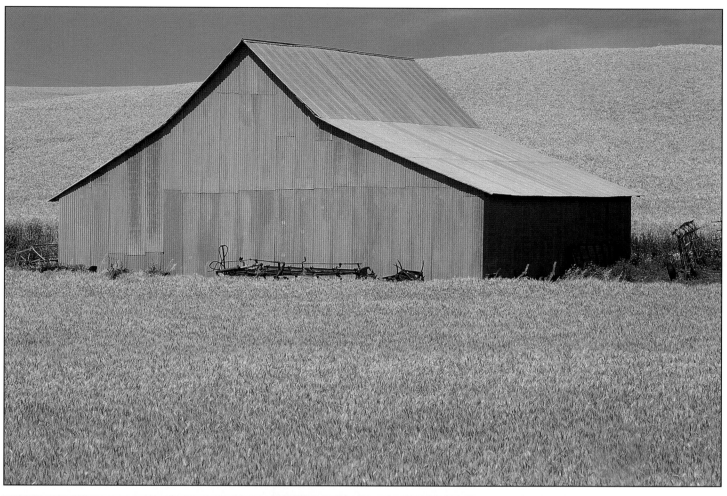

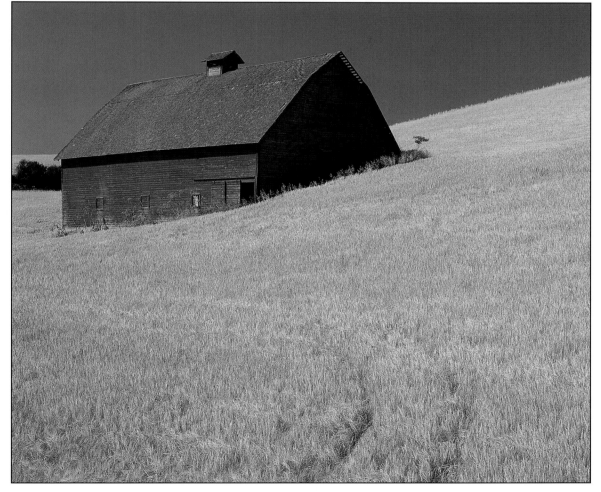

opposite page top left: This weathered barn displays classic vertical planking, White River Junction, Vermont.

opposite page top right: Double A-frame barn in snow, Tualatin Valley, Washington County, Oregon.

opposite page bottom: Snow-covered field and barn at the base of Chugach Mountains in Palmer, Alaska.

top: A barn sits surrounded by wheat fields west of Tekoa, Washington.

bottom: A simple, classic barn structure amid a field of barley in the Palouse region of eastern Washington.

exhibit no clear preference, possibly determining placement according to weather exposure rather than custom.

Enough barns follow traditional patterns to make an informal study of them a pleasant way to have the miles fly by on a cross-country trip. Be observant, and you'll learn what to look for as you drive along.

Door on side

Appalachian

Acadian

Double-crib

English

Erie Shore

German

Gothic or round roof

Pole

Potato

Quebec long

Raised

Swedish

Three-bay threshing

Three-end

Tobacco

Door on end

Cajun

Crib: Single-crib, Drive-in crib,
 Four-crib

Dutch

Czech

Feeder

Finish cattle

Finnish meadow (hay)

Madawaska twin

Midwest three-portal

Transverse frame

Welsh gable-entry banked

Welsh one-story

Wisconsin dairy

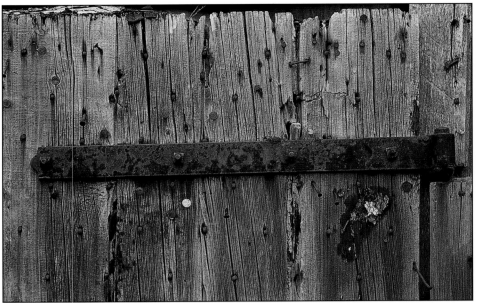

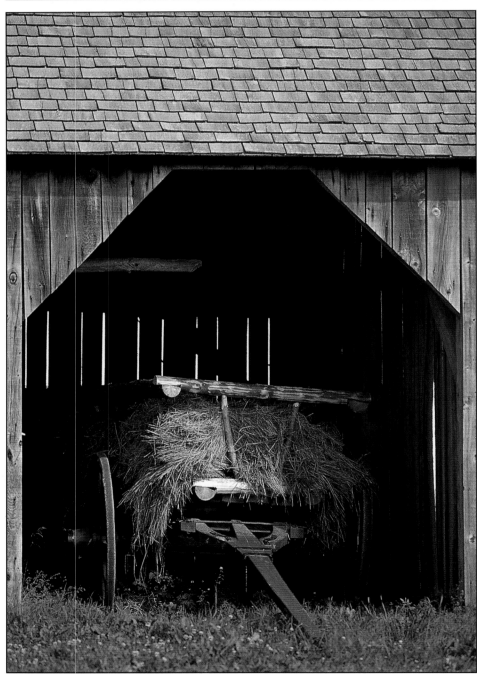

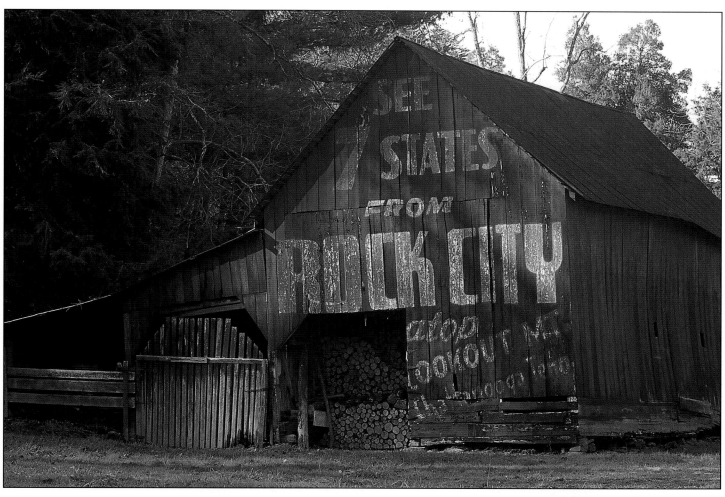

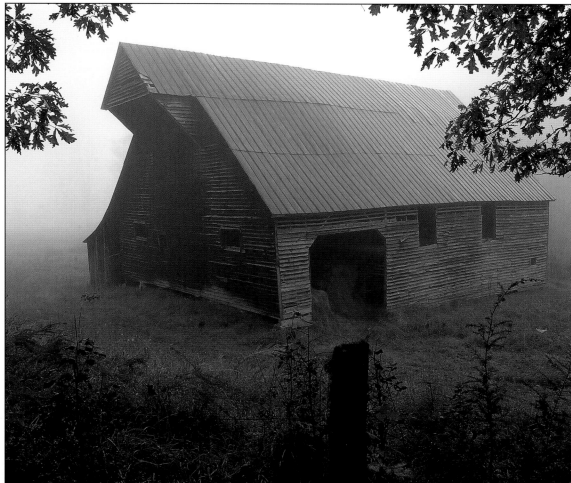

opposite page top: The well-worn face of a rusting barn door hinge.

opposite page bottom: Hay cart inside the doorway of a barn in Kings Landing, New Brunswick, Canada.

top: "See 7 States from Rock City" painted on a red barn, located in the Tuckaseegee Valley, Bryson City, North Carolina.

bottom: Barn on Loop Road in Cades Cove, Great Smokey Mountain National Park, Tennessee.

51

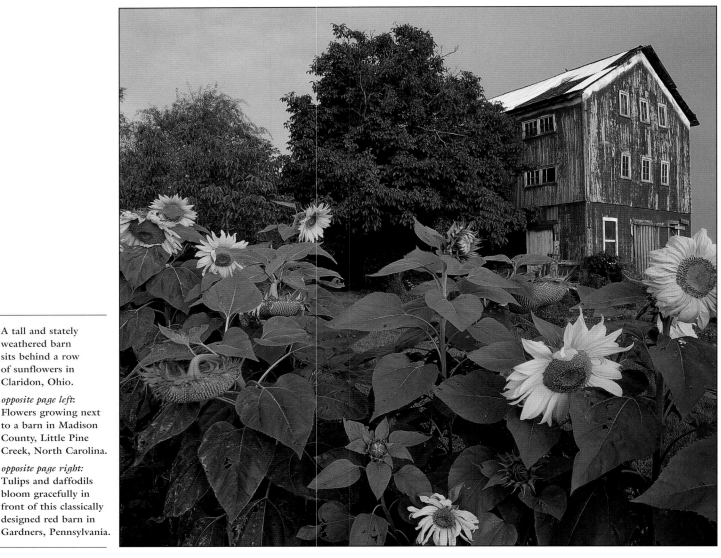

A tall and stately weathered barn sits behind a row of sunflowers in Claridon, Ohio.

opposite page left: Flowers growing next to a barn in Madison County, Little Pine Creek, North Carolina.

opposite page right: Tulips and daffodils bloom gracefully in front of this classically designed red barn in Gardners, Pennsylvania.

Certainly, if barns *could* speak, they would tell of brave families arriving in the New World with dreams of independence and freedom to worship—treasures paid for in unending physical effort, scarcity of material goods, bitter cold in the winter, heat and thirst in the summer, insufficient shelter and food, and all the other challenges, hardships, and dangers that we know from the pages of history books. A well-built barn was a crucial element in the ability to survive and even thrive.

Approximately twenty major ethnic groups could have brought their barns to North America, all of them farmers from temperate or cold climates. Apparently, only eleven groups actually transplanted elements of their native designs. It is interesting to speculate about the reasons why the immigrants retained elements of their traditional barns and also adopted other approaches to design and building.

English influence

The English were among the earliest farmers among the immigrants, spreading across the continent, enduring wherever they settled. They and others brought ideas with them, but the new world barns tended to be a true melting pot of ideas. English settlers frequently built barns with foundations of stones or large rocks—less often but when available, with brick. Other groups built similar barns but included the ethnic variations connected with their European heritage.

One of the most common designs was the *three-bay threshing barn*, a timber-framed, post and beam structure that depended upon a ready source of large trees and skill in mortise and tenon construction. The *bays* expressed the equal distance from post to post on either side of a central aisle that was itself the dimensions of a bay. In the aisle, threshers used flails to beat the opened sheaves. The resulting grain and chaff was shoveled into a winnowing basket and shaken; the heavier grain fell onto a sheet on the floor. As an alternative method, the farmer threw the grain and chaff up in the

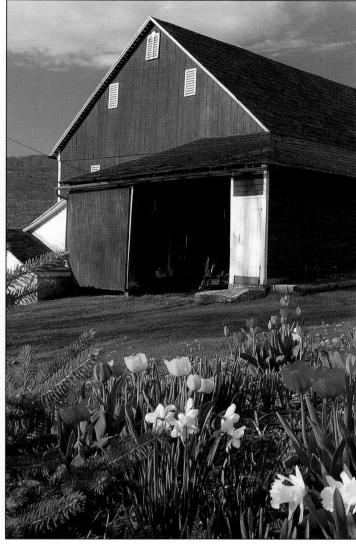

air so that the chaff would blow away. These were single story barns with side gables and a loft above the main floor for hay storage. The low foundation was built of stones or large rocks. The roof was steeply pitched and, in the early barns, the pitch was necessary to allow a thatched roof to drain and dry out. Although thatch was cheap and effective, it also was vulnerable to fire, so that as soon as possible more farmers turned to hand-hewn shakes or shingles. The plank siding was vertical rather than horizontal to guard against rot. Windows were far too costly to consider for the barn, but there were always small ventilation openings high on the gable ends. Damp hay

invited spontaneous combustion—making the ventilation supplied through the cracks between the siding planks as well as the hayloft ventilators extremely important. Farmers might add gable end sheds, especially in the mid-West where a shed would be made of unhewn notched logs in Mormon Utah while those in Wisconsin were barn-length sheds under an extended roof of the main barn, creating a saltbox silhouette.

Another familiar English barn, a New England trademark to this day, is the *connected barn*. Inspired by severe winters, there were usually four sections—house, little house, back house and finally, the barn. The number of sections actually

could be as ambitious as the farmer wished, covering the full day's activities, which then became capable of being performed in the worst weather. (Anyone who has ever experience a white-out in a snowstorm can appreciate the comfort of knowing you can feed the animals without getting lost—or having to struggle through the storm hanging onto a rope to find the way back to the house.) The usage of the center sections depended on the individual family's lifestyle, but the purpose was to allow most normal activity without having to brave the snow and cold. Connected barns sheltered the house itself from the smells and noises of the barn, taking the farmer through a few

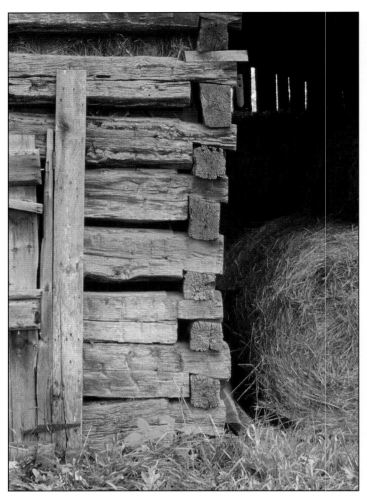

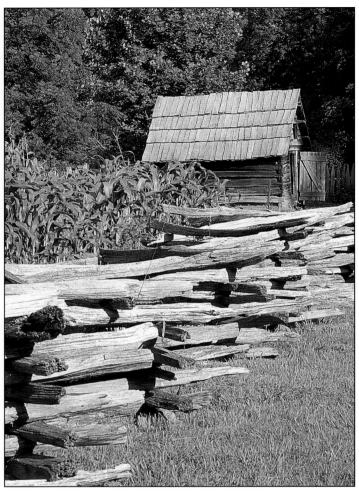

top left: Log barn with round hay bales inside, Little Island Creek Valley, near Pipestem, West Virginia.

top right: A split rail fence, corn patch, and log chicken coop in the Great Smoky Mountains National Park in Swain County, North Carolina.

bottom: Cantilevered barn, Tipton Oliver Place, Gatlinburg, Tennessee.

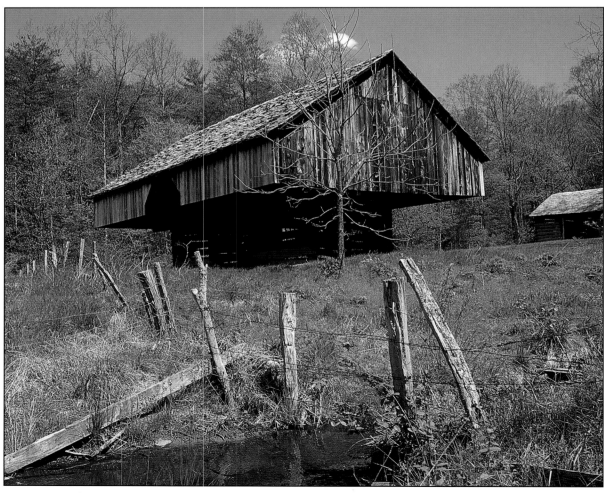

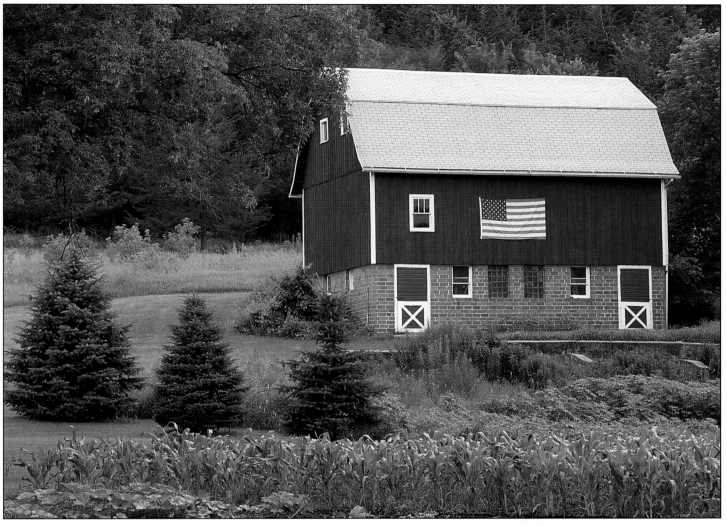

Barn with an American flag painted along its side in Minnesota.

sheds on his way to the cows or horses, allowing him the convenience of shelter from weather without his family truly feeling that they lived in a barn. From time to time, the danger of a barn fire spreading to the house discouraged the choice of a connected barn—or even caused a farmer to move the house away from the barn.

The *English bank barn* was another variation, utilizing sloping ground to allow entry on two levels. The lower level was for the animals; the upper one resembled the three-bay threshing barn. These barns are found in eastern New York, western New England and northeastern Ohio.

The *raised barn*, with dimensions that ran 30 to 50 feet in width and 60 to 100 feet in length was raised on stone, brick or (eventually) concrete foundation. They were generally on level ground with second floor threshing doors opening to the rear or downslope side. Doors to the lower level appeared on the gable ends or below the threshing doors. A dirt ramp or barn bridge gave access to wagon doors at the top of the foundation that could have a covered-roof entry. These barns were built primarily in New York, Vermont, the upper Midwest, western Pennsylvania and northeast Ohio.

The *foundation barn* is an early variation on the raised barn. In many ways identical to raised barns, it is a single story with a fieldstone foundation, no windows, gable roofs and vertical siding. The main differences are the absence of an entry to the second level using a ramp or bridge, and the placement of the main wagon door in the gable end. The foundation barn was built in central New York and northern and central Wisconsin.

Welsh influence

Although nowhere near as widespread as the English and German designs, the Welsh gable-entry barn has contributed its own set of modifications. The raised barn and foundation barn evolved from this type can be found in Western Kentucky, southern Indiana, Illinois and on through the central

Midwest. One unusual feature is that the gable wall may be longer than the side wall. The ridgeline is perpendicular to slope with the upslope entry through gable end and the lower level or basement entry in the opposite gable. These barns have two floors and a loft.

German influence

Moving from English barns to the contributions of the European immigrants, the Germans made a major impact. The numbers of Germans arriving on the continent in the 18TH century were modest but the 19TH century changed the picture entirely. Huge numbers of German settlers moved into Pennsylvania, and from there across the Great Lakes states to western Washington, south through Colorado, Kansas, Missouri, and Illinois. There came to be fair representation also in New York, Texas, northern California, Oregon, the Canadian plains, and Ontario. Barn authorities seem to agree that more than fifteen types of barns bear the mark of German influence.

The German barn is common from eastern Pennsylvania to the central Midwest. The most distinctive element is the forebay as an extension of the second floor beyond the foundation wall on the downslope side, with a symmetrical roof covering both the main barn and the forebay. Otherwise, the barns are similar with small differences in detail. The details to search for are 1) that there is a forebay 2) how the forebay is supported, and 3) the depth of the forebay. Almost all forebay barns are banked, but not all

A classic image: A farm with a red barn surrounded by a white fence in Oregon, Pennsylvania.

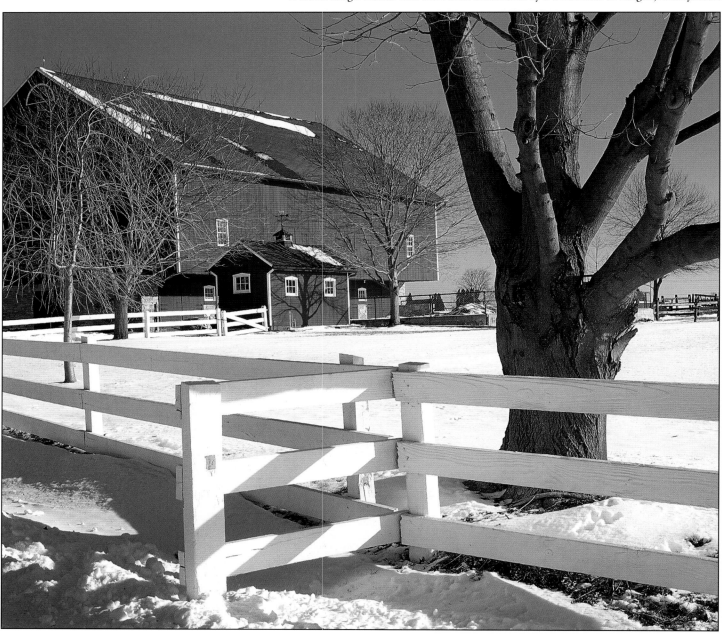

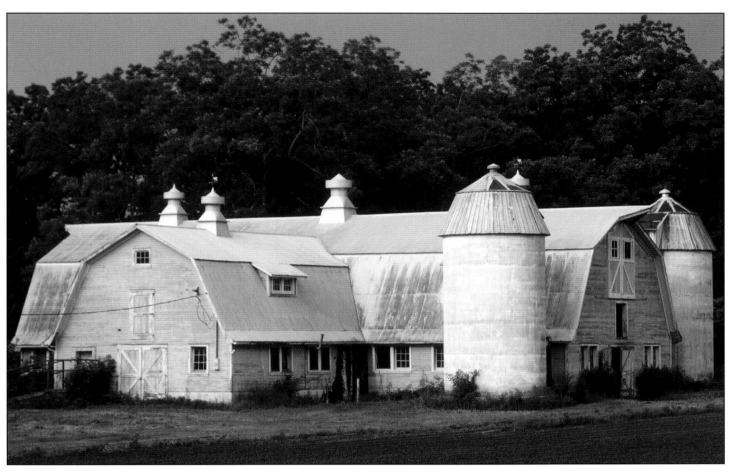

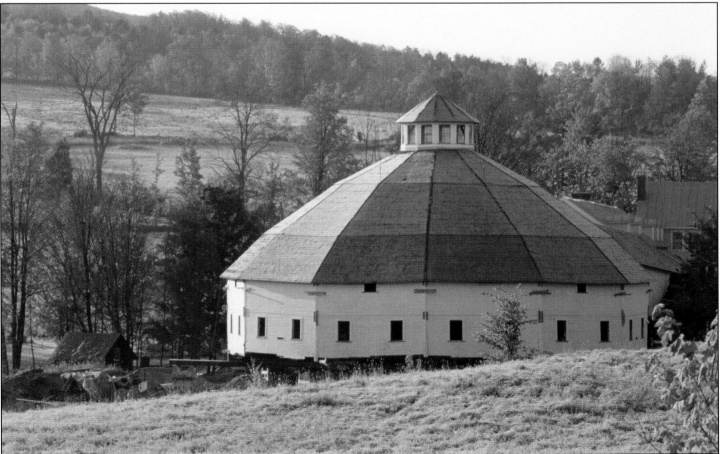

Top: A fading yellow barn with silos in Louisiana.

Bottom: A round white barn in Warren, Vermont.

Overleaf: Built in 1918, this traditional red barn is found near Gennesse, Idaho.

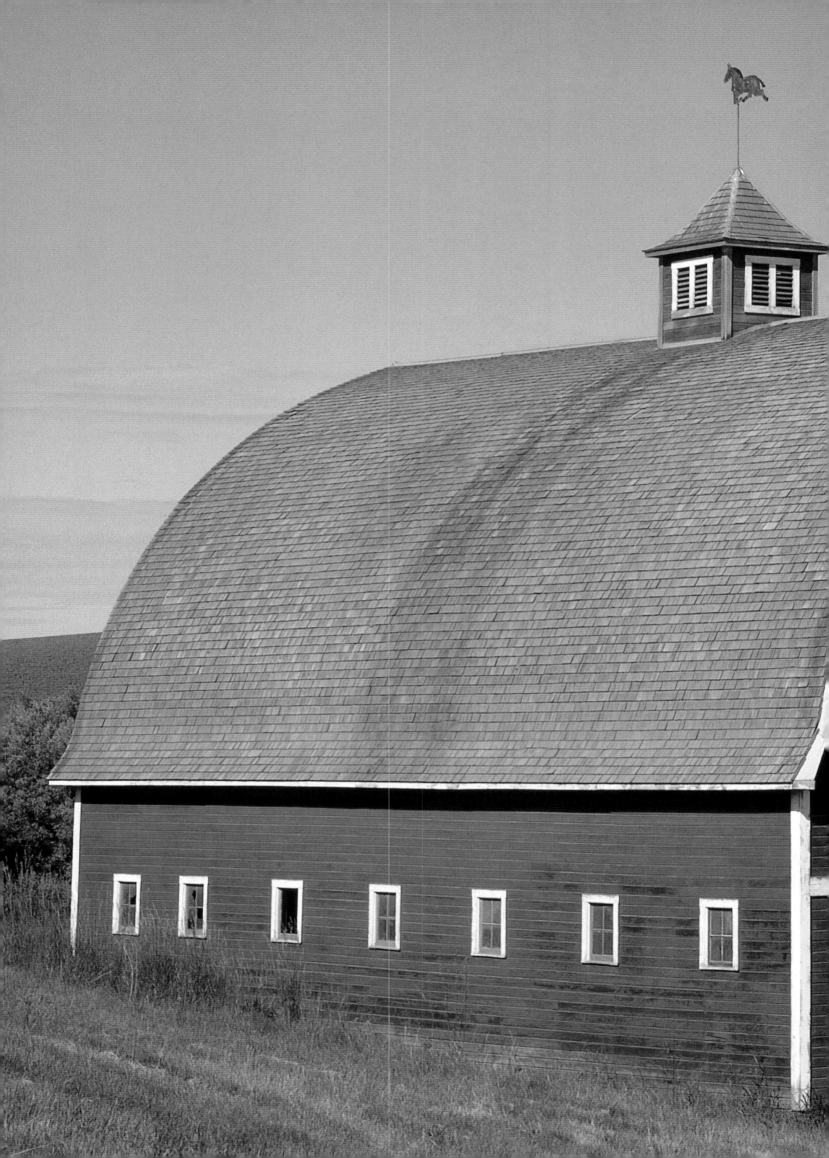

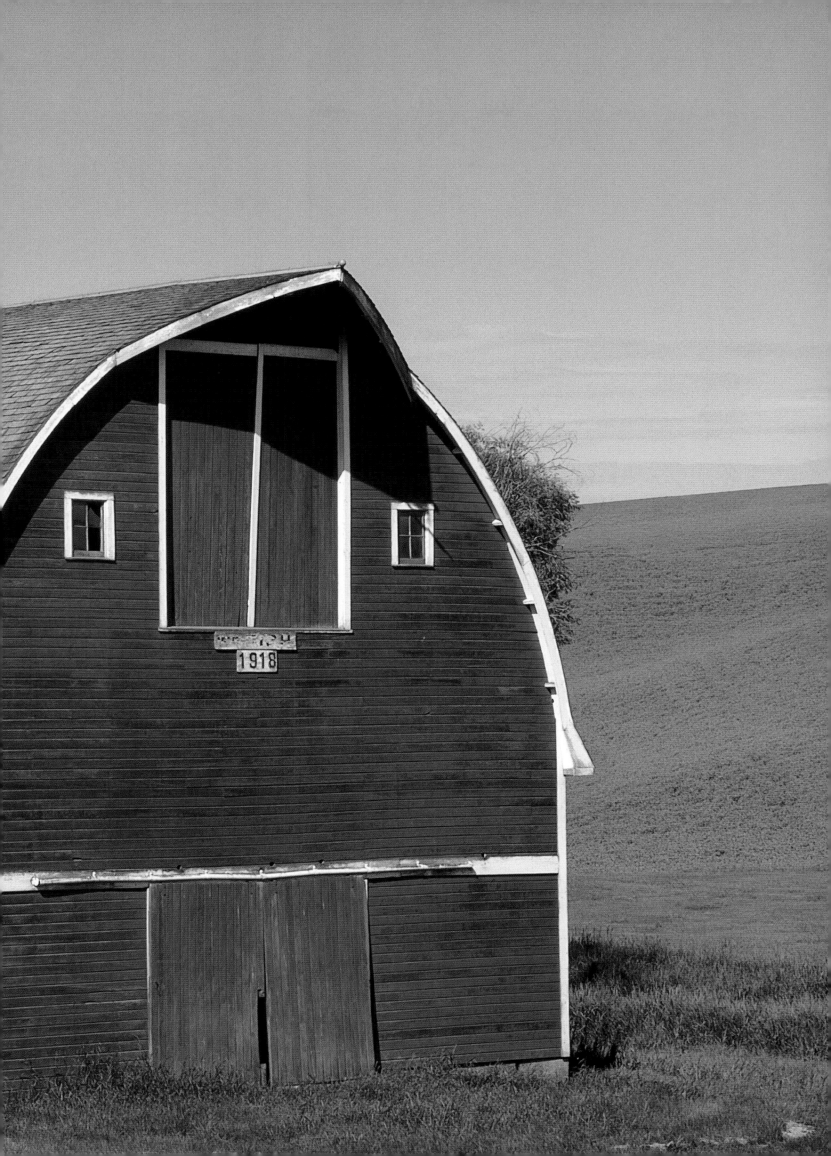

A pretty autumnal scene: red barn and fall foliage in Ohio.

bank barns are forebay barns. These barns have the clearest roots in German Europe. The others seem to have been developed in southeastern Pennsylvania.

The *Grundescheier* or ground barn may be found on flat land but more often appears on slopes, with three bays and possibly a gentle ramp to the wagon doors. The closely related *Sweitzer* or Swiss barn is most often three bays by two bays with cantilevered beams supporting the forebay overhang on the downslope side. The forebay is always tim-

ber frame with plank siding. In contrast to the German barns where the forebay is included under a symmetrical roof line, the Sweitzer has an asymmetrical roof. The barn may be half-timbered, log, timber frame, brick, or stone. Inaccessible threshing doors open above a stable yard and double wagon doors are set into the upslope side. Frequently, Dutch doors under the forebay access the basement level. In southeastern Pennsylvania, the basement or ground floor wall may be extended to enclose the forebay.

The barn that has become the standard Pennsylvania barn

Pennsylvania is probably best known for its involvement in the creation of a new country. Thousands of people visit Independence Hall and the Liberty Bell each year or learn about famous citizens, William Penn and Benjamin Franklin. However, the influence of the Pennsylvania barn throughout the country is a quiet, but equally as important a contri-

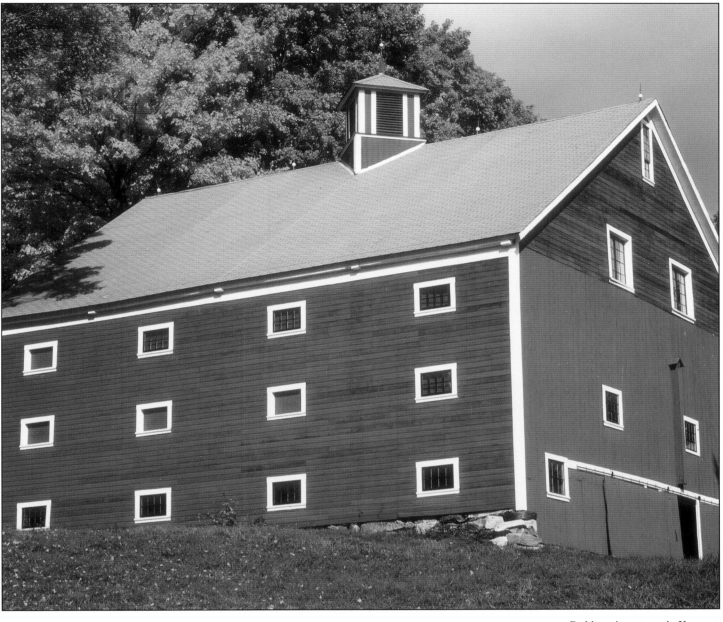

Red barn in autumn in Vermont.

bution. Even today, when the East Coast is replacing much of its farmland with housing developments and business parks, Pennsylvania's major economic factor continues to be agriculture and the related support systems. There is no accurate register of barns to determine how many of the old standard designs are still in existence, but in driving major roads across the state there are plenty of old barns to be seen.

Generally, in identifying a Pennsylvania standard barn, look for a symmetrical gable profile, with the forebay incorporated into the main barn but with a roof pitch of 30–35 degrees, less than the main roof. These barns can be found from Pennsylvania to Wisconsin, in Virginia, southern Ontario, somewhat infrequently in Missouri, southeast Iowa, and Erath and Bell Counties in Texas. Within the general description, there are identifiable modifications:

The *closed-forebay standard* is marked by stone gable ends and an enclosed forebay less than 6 feet deep.

The *open forebay standard* has a fieldstone foundation and upper level construction of frame. The forebay is contained within a framing system and is cantilevered over a downslope feed lot. The gable profile is symmetrical.

The *posted forebay standard* uses wooden posts to support a wooden frame forebay that may run up to 15 feet deep. Gables are symmetrical and the end walls resemble those of the open forebay. Look for these barns in Pennsylvania, Virginia's Shenandoah Valley, southern Ontario,

Ohio, Indiana, Illinois, Wisconsin, and a small scattering in Iowa.

The *multiple overhang standard* is unusual for the presence of an overhang on more than one wall, possibly appearing as a 1 to 2 foot extension on the gable wall. On the upslope wall it will be 2 to 6 feet, but never more than the traditional forebay overhang. Found in Pennsylvania and the Midwest. Clusters of these barns appear in Virginia, Ohio, and Indiana.

The *basement drive-through*, although different, still ranks as a standard Pennsylvania barn. The drive-through may be a space created by the addition of an extra bay, or by placing the main bank entrance off center.

Specialized forms reflect ingenuity on the part of the farmer but appear in limited numbers.

A few *gable ramp barns* survive in Berks County, Pennsylvania.

Gable forebay barns may be searched out in Berks and Montgomery Counties, Pennsylvania. A few remaining *stone arch forebays*—stone wall forebays, pierced by romanesque arches still stand in southeast Pennsylvania and New Castle County, Delaware.

Truly rare are the *bank into forebay barns* where the forebay is built on the upslope, and is entered directly from a ramp. Only four examples are mentioned: two in Bucks County, one in Centre County, Pennsylvania, and one in Morgan County, Missouri.

And even within the territory of the well respected Pennsylvania barn, the *extended Pennsylvania barn* deserves special mention. It is banked, stone or wood, with a very large forebay that appears to be attached rather than integrated, resulting in an asymmetrical barn roof. The roof pitch is less than the main barn. The forebay is supported by large posts.

The *extended supported forebay* has tapering stone piers and extends 15 to 20 feet from the barn. A cross-beam connects tops of piers, forming the base for the outer forebay wall. This barn is a combination of German and English influence.

An *up country posted forebay* is supported by wooden posts, and there is often a gable dormer over the forebay. The area under the forebay may be enclosed by a fieldstone foundation. The barn itself is long and generally lower than the Sweitzer and is 5 to 7 bays wide. There are often several pairs of threshing doors. Louvers on the side and gable ends provide ventilation. Generally found in southeastern Pennsylvania, central Mary-land, Virginia, and Wisconsin.

Frontshed extended is an L-shaped barn, often a downslope addition to a large gable-roofed structure. It has a forebay of its own.

Outshed extended barn adds, on upslope side, a 12–15 feet granary outshed.

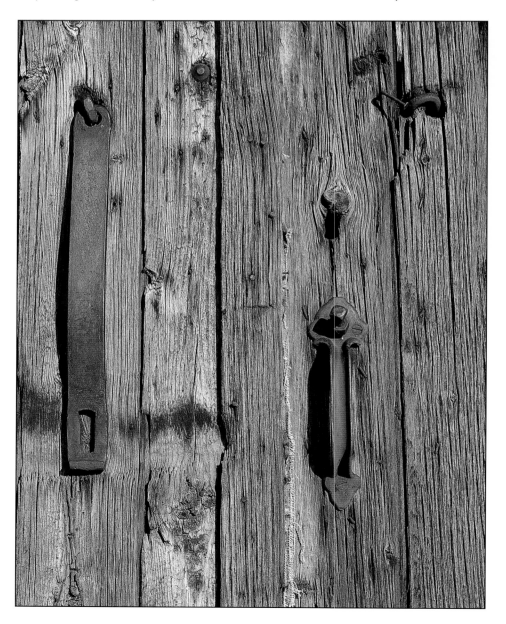

Left: A lovely feature of this weathered barn door are its handle and clasp.

Right: Pioneer barn in autumn, Pend Oreille Valley, Washington.

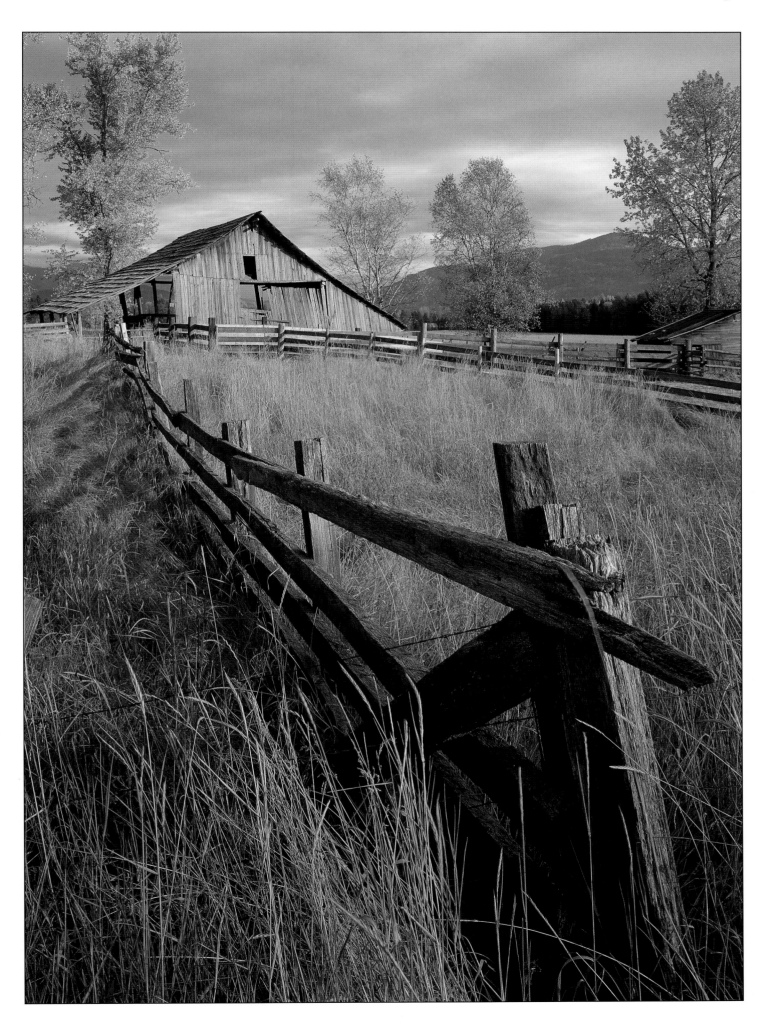

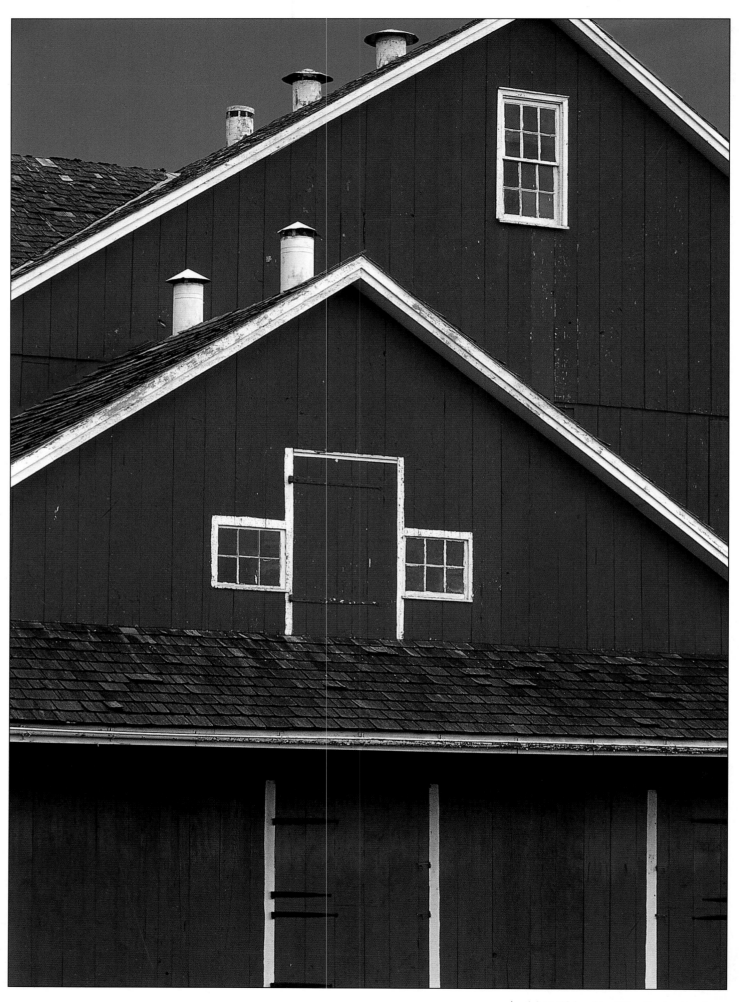

A beautiful and traditionally structured
red barn in Lancaster County, Pennsylvania.

CHAPTER 6

Strictly Structure

It is one thing to know the heritage of barns and the purposes for which they were designed and quite another to understand how to build them. Most of the basic skills were acquired in response to urgent need, and then those skills were honed by experience. Certainly some of the early crib barns were crude and poorly assembled, but they provided shelter and that was the primary consideration.

Even the relatively small number of immigrants who brought carpentry or cabinet-making skills with them were far from their former lives, and log cabins and barns were the need of the moment. Structural design evolved from the nature of the building materials. The detailing developed in response to the purposes for which the barns would be used.

Foundations

The primary purpose of foundations was to separate the wooden structure from the dampness of the ground in order to avoid rot. Even the simplest of log cribs sat upon large corner stones in order to raise the sills. Where stone and brick were used for foundations, they might be low or actually become part of the walls. The most commonly used stones were limestone, sandstone, and fieldstone. These foundations were dry wall construction, a matter of fitting stones together carefully so that their shape and weight supported the walls above.

Walls

Walls began with the search for easily available wood of the appropriate varieties. The farmer clearing his fields set aside plenty of raw material for building log cabins and barns. He had to handle individual large logs with the help of his family. His ax was the multi-purpose tool with which a building could reasonably be completed. The goal of his forest inventory was tall, straight trees that made good timbers for barns primarily found in the northeast. In Pennsylvania, there was an abundance of white oak, chestnut, and tulip poplar. Oak was valued for its strength, the fact that it could be cut to use for dramatic spans in the big, timber, framed barns. Choices were made according to supply and cost. Iron nails were extremely scarce and expensive, leading to the use of mortis and tenon joints, stabilized with wooden pegs from the white oak trees.

The builder planned his barn carefully. If he intended to work with post and beam construction, the most prevalent factor was where timber was plentiful. He would make a long list of structural members that would have to be first cut and then hand hewn to the appropriate shapes—from huge beams down to small pegs. The list would include:

• A swing beam—the long, strong beam that supports the hayloft without interim posts

• All the verticals, known as *posts: end, corner, side, interior*

• The beams—all the horizontals

• Sills—beams at the base, resting on the foundation

• Plates—beams at the tops of side walls

• Tie beams—connecting front and back

• Braces—short diagonals

• Mortise and tenon—two pieces of wood fitting together, one with a notch cut into the end which also has a hole at right angles about half way to the end of the notch, the other with a projection carved so that it will fit into the notch. The projection has a drilled hole matching the peg hole in the mortise. From the outside of the joint, a peg is driven all the way through both pieces of wood, creating a very strong connection.

Every barn has at least four sills and two plates. All posts, beams, and braces have been prepared for mortise (notch) and tenon connections. Besides ax, hammers, sledges, block and tackle, the builder needs pike poles to use during the barn raising, and of course an evergreen branch for the topping out ceremony after the last set of rafters

was set in place. Raising a timber barn was the earliest expression of modern prefabrication!

And then, assuming that the foundation was laid, all the timbers were cut, the mortises and tenons prepared, and every piece of wood that contributed to a strong frame was ready to go, the farmer called in his friends and neighbors for a

barn raising. The big timber frame barns had to have neighbors. They were impossible for the isolated settler to assemble single-handedly, which is why so many crib barns were built all across the continent. Raising a barn was hard work, but it was also an excuse to get together, to enjoy companionship as a break in the often lonely routine.

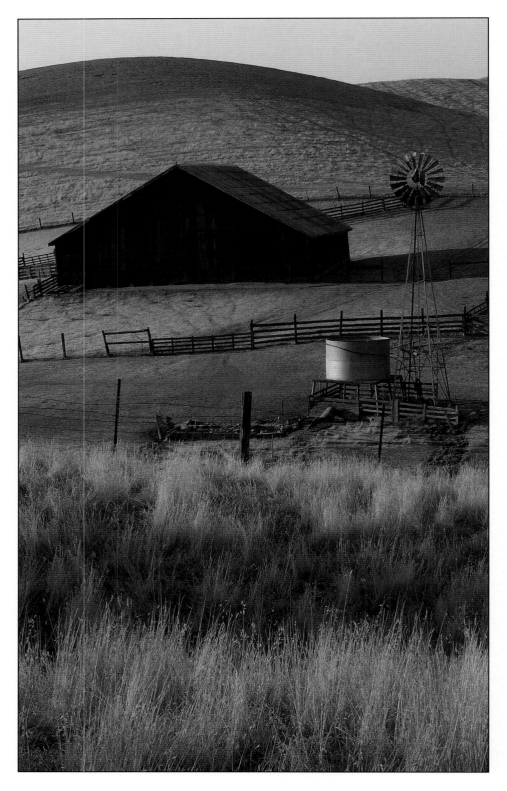

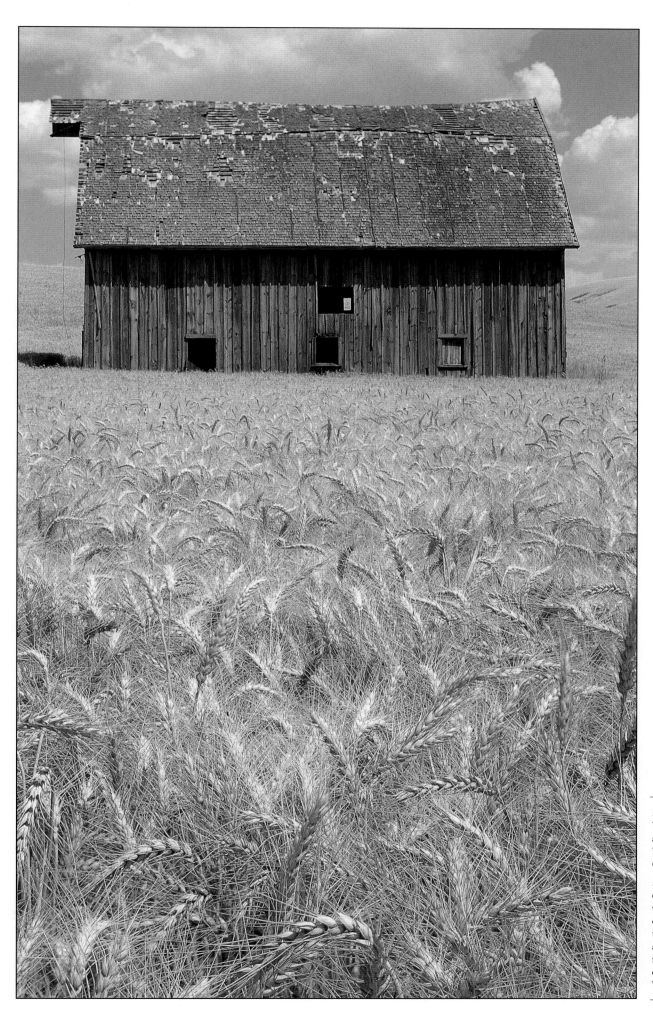

Left: Sacramento Valley Barn and windmill, Yolo County, California.

Right: This dilapidated barn with its long eaves to shelter the wood sits alone in a wheat field southwest of Colfax, Washington.

This is a highly simplified description of a barn raising, but the day would begin by 1) setting the largest beam or girder into slots on the foundation wall, letting it rest also on at least two posts already set in the ground to support its center sections. 2) Placing the sills, already prepared with the mortises or notches to hold floor joists on the foundation. 3) Inserting the joists. 4) Laying the floorboards on top of the joists but not nailing them down until after the raising is complete. 5) Preparing to lift the first bent—the posts and beams, ties and braces ready on the ground, and attached one piece to the other with pegged mortise and tenons. 6) Raising the bent with many hands with pikes to push it upright, aided by the block and tackle, and pegging the ties in place to connect the bents around the outside. 7) Mortising the posts into the sills and girder. 8) One by one raising of the remaining bents and connecting them. Now the barn was ready for plates and rafters.

The oldest barns, the cribs, were of horizontal log construction. They might be chinked, but more often, were left unchinked to allow for ventilation. When sided with planks, the log structure was no longer visible. Timber frame barns were sided with planks applied vertically to prevent rain from collecting between the individual planks and causing rot. Horizontal planks are much less common but can be found in New England, among the Dutch barns in New York and New Jersey, and in Wisconsin after the Civil War. Also, house carpenters often rebuilt the barns in the Shenandoah Valley of Virginia after the Civil War and horizontal siding was their preference—a habit left over from pre-war house construction. Shaker walls of cedar or pine could be found on the coast of New England, especially in Maine and also in New Jersey.

Variations on the basic crib and timber frame barns developed quite early in the immigrants history. Europe's half-timber style did not travel well to the new colonies. It was rarely found in North America, and only in the early German barns. In later years, half-timber walls were often covered by clapboards. In the Midwest, walls of an early lumber frame barn were filled with packed mud. Short lengths of round log, or possibly split half

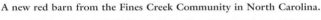

A new red barn from the Fines Creek Community in North Carolina.

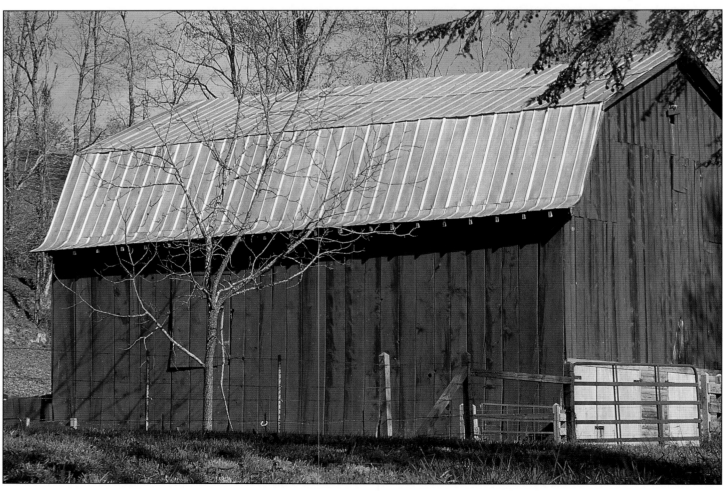

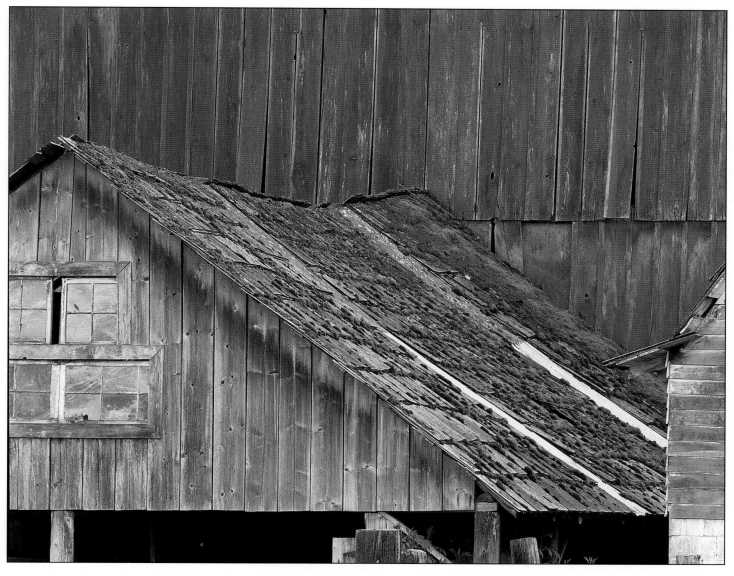

Shingled roofs with lifted eaves to offset rain are highlights of this old Washington barn.

logs, were piled up with one end of each log exposed to the outside and the spaces between filled in with mortar. These were rare and limited to the upper Great Lakes and Canada. Cobblestones were occasionally used in walls, and also could be found in the foundation of timber frame barns, mostly in central and western New York, and also around Paris, Ontario and Beloit, Wisconsin.

Roofs

Gable roofs are the most familiar, the roofing style found all over Europe and the Americas, virtually from the begin-

ning. They probably appeared with the first thatched roofs, already mentioned as needing the steep pitch to allow the thick straw covering to dry after a rain or snowstorm. Thatching as a cheap material was appealing, but the technique didn't last long in North America with its strong winds and long winters. The plentiful supply of wood accounted for the substitution of planks and shingles that not only proved more durable, but also made for more flexibility in determining the pitch. Sheds attached to the main barn could be built with a gentler roof slope.

The same ingenuity that marks barn

design over the decades extended to the roof design, too. Along came the *gambrel* roof which provided much more loft storage in return for slightly more complicated construction. The edge of a gambrel would frequently have a flare or kick to deflect water away from the barns foundation. Gambrels might be new construction or represent replacement of an older gable roof. The ultimate in adding hay storage was the round roof, never a particularly popular option. A close cousin, the *hip roof*, sloped on all four sides but supplied nowhere near the loft space of the gambrel.

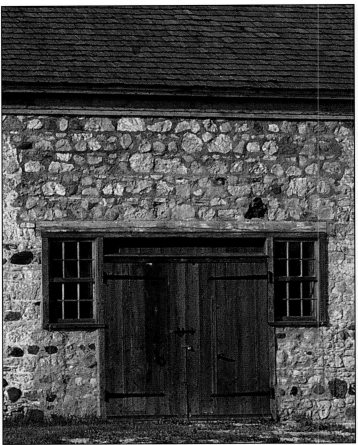

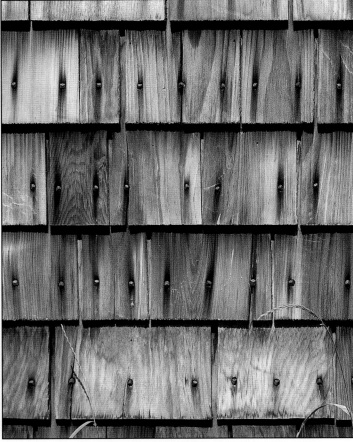

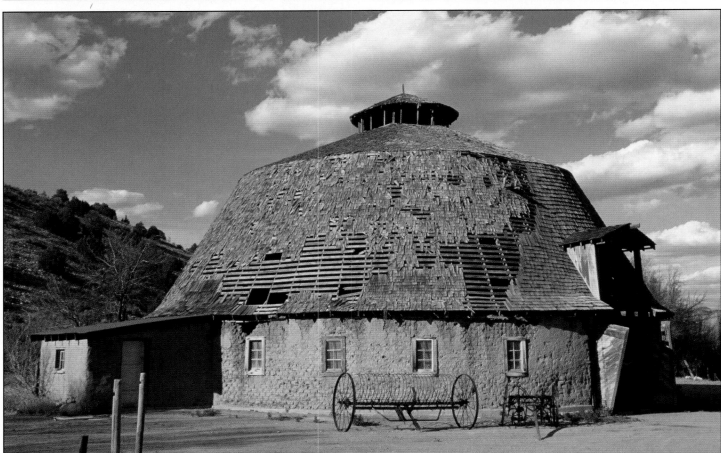

Top left: This stone barn (Elam Beardsley Farm, est. 1843) is located in Racine County, Wisconsin.

Top right: A detailed look at the shingled face of an old barn wall.

Bottom: An old round barn with missing roof shingles, near Ojo Caliente, New Mexico.

Opposite page: Maple boughs frame a Missouri barn in Washington County, Ozark Mountains, Missouri.

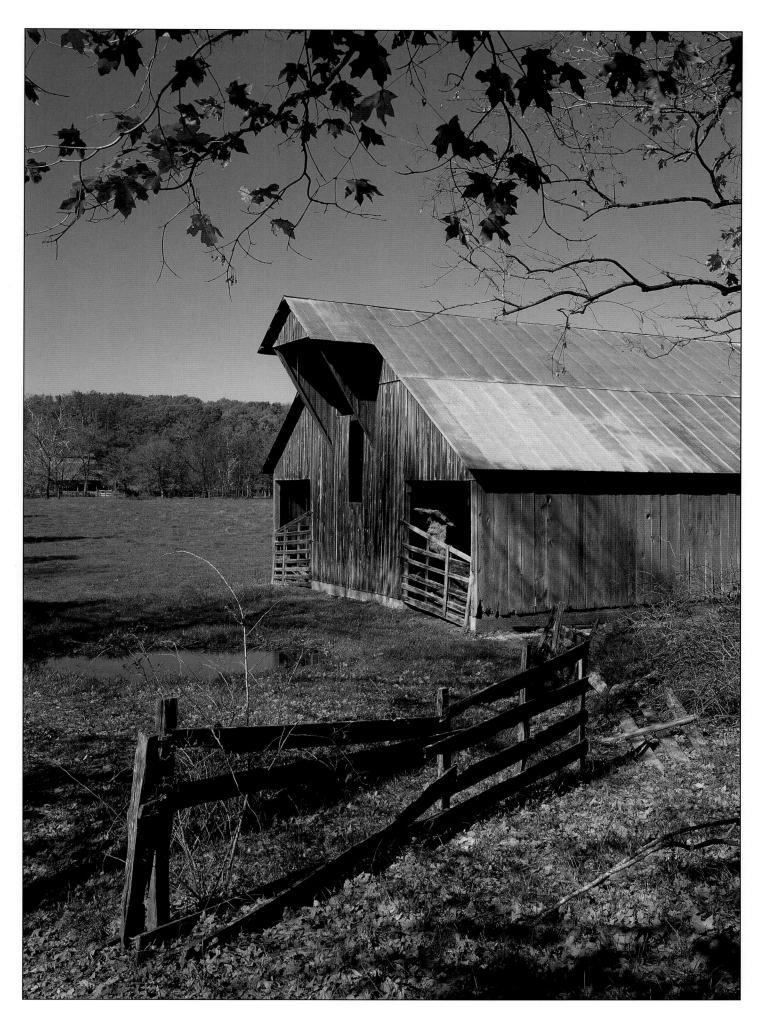

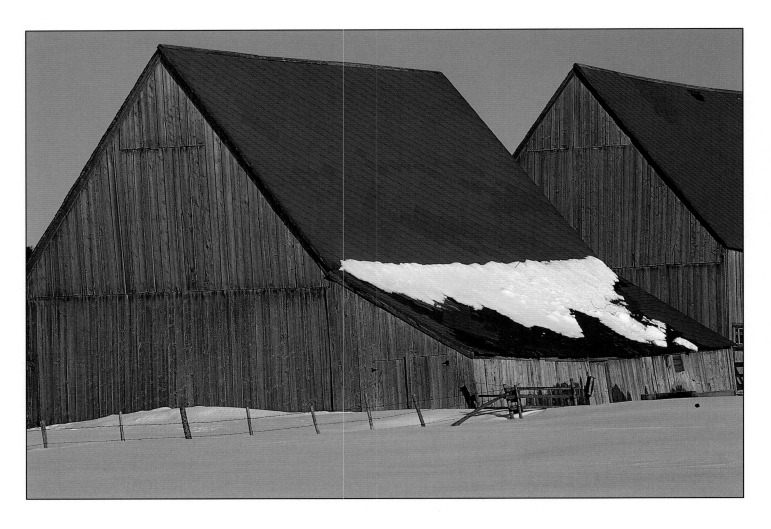

Saltbox roofs are relatively common in New England, on both barns and houses. They have the same slope as the gable section but with an extension over an attached shed. The original purpose of the saltbox roof is exhibited by its orientation with the long side toward the north for weather protection.

The *monitor* or *clerestory roof* appears where additional ventilation has been the goal and is not specific to a geographic area.

Pent roofs are often found over doorways for shelter from rain. The pents on barns are larger, actually providing outside shelter. If they appear on the side, there is a relationship to the cantilevered forebay of the German barn. A pent on the gable end has a connection to English barns with sheds attached to gable end found in southern Michigan, eastern Indiana, western Ohio, and southeastern Pennsylvania. A small pent over the main barn doors is called a pentice, which is quite common on Dutch barns. Hay hoods can also be called hay bonnets and, as the name suggest, they project over a hay loft door and shelter the pulleys from the weather.

Ventilators

Barns need ventilation, and some barns need extra ventilation. One option is a Lancaster ventilator, an overlapping triangle over a gable peak opening, 6 to 8 inches beyond the wall line. Cupolas—not for seeing but for ventilation—can be found anywhere, from coast to coast, north to south, four-sided, hexagonal or whatever appeals, topped with fancy roofs, weathervanes, lightening rods—fancy or simple as the farmer wishes. They are most prevalent on dairy farms in northern Midwest, northeastern United States, and eastern Canada. Slit ventilators or decorative brick work patterns may be of local design, the mark of a builder, or a recognizable ethnic feature.

Tobacco barns are a case in themselves, reflecting different opinions about how best to dry the tobacco. They have a raised ridge, metal ridge vents, or especially with the Amish, wall panels that open outward.

Dormers provide both ventilation and light and are more apt to be gabled than shed in design. Shed roof dormers are the earlier design, while the gable appeared during the latter part of the 19th century.

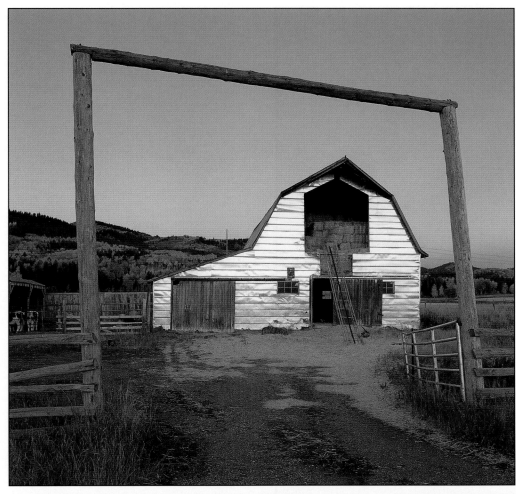

Left: Two white barns with steeply sloped red roofs in New Brunswick, Canada.

Top right: Dawn breaks over farmyard and aluminum covered barn in Teton Basin, snake River Range, Idaho.

Bottom right: Pegged barn beam near Stanhope, Quebec, Canada.

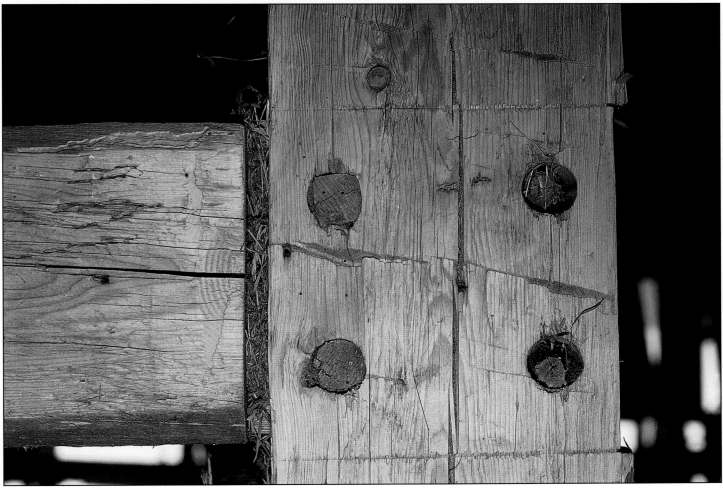

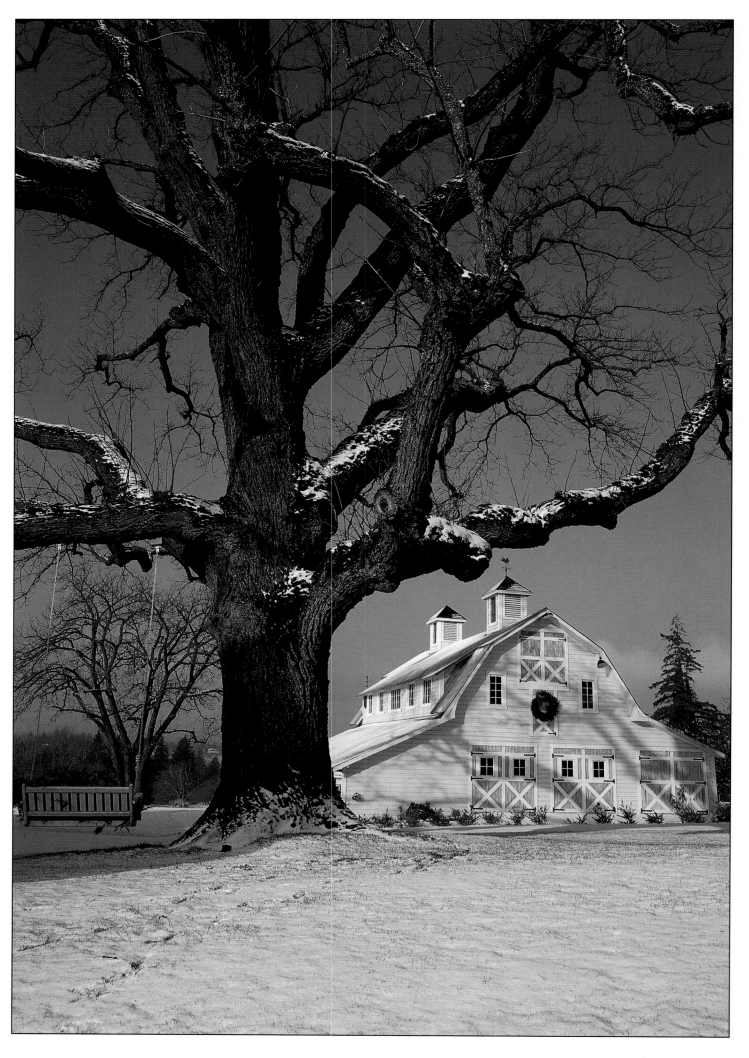

Barn bridges and entry porches

In bank and raised barns, the access is usually from the side. If there is a bridge to the hayloft doors, the space under the bridge may shelter equipment. Similarly, a ramp can serve as sheltered entrance to a root cellar hollowed out under the ramp.

Occasionally an entry porch is built on the side of a barn with a gabled roof and two side walls. This addition can be combined with a barn bridge for a large entry porch.

Windows

Not many barns have the luxury of windows, but dairy barns generally have more windows. They seem to follow a haphazard pattern, being added when and where the farmer has needed the light. Usually found high in the gable end, a pair is rare, while a single window may be a rectangle or a square tilted to follow the line of the gable. Variety appears in portholes, or even half-rounds which appear more often on carriage houses than barns. Substitute openings are found in the gable ends, covered with louvers. A somewhat whimsical adaptation, owl holes in the gable walls take the form of geometric figures, can be in multiples, and are both decorative and useful.

A door light, not really a window, was an opening for light over the wagon doors. In older barns it was originally fitted with a hinged lid to drop when the weather was bad. Door lights were often replaced with small windows.

Left: **A picturesque yellow barn accompanies a tree swing during the winter in Oregon.**

Right: **This barn door boasts heart-shaped barn hinges in Quebec.**

Doors

A door is a door? Even within the predictable barn doors there can be variety. Most are rectangular for ease of handling, and sized somewhat larger either for animals, wagons and equipment or somewhat smaller for humans. After the 1880s, sliding doors were developed for most of the larger openings where hinges were previously used. The hinges were adapted from those used on freight cars. A big door on sliders instead of hinges reduces the danger of damage from high winds.

In the eastern half of the United States and in Canada it is not unusual to find a door in a door—a small door built into one of a pair of large doors. Pennsylvania German barns often feature Dutch doors on the lower levels, allowing ventilation but keeping animals from

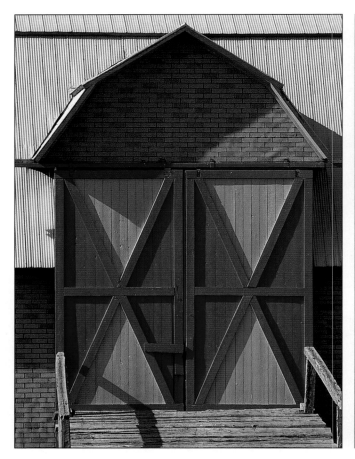

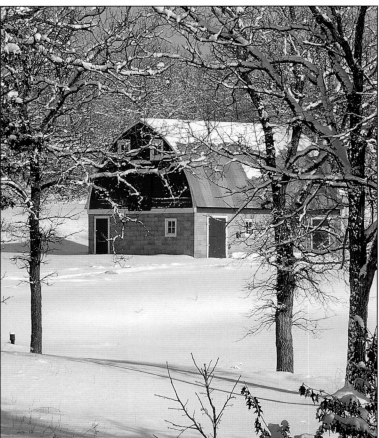

Left: These beautiful barn doors can be found in Saint Simeon, Quebec.
Right: Red barn winters in Otter Trail County, Minnesota.

wandering in from the barnyard. Doors with rounded tops appear in Quebec long barns but can also be found on some stone German barns, specifically in French Canada, Chester County, Pennsylvania and Gasconade County, Missouri.

Sheds

During the 19TH century, the increased production of grain with its side crop of straw for animal bedding led to a rectangular extension to the rear of many barns. This adaptation or straw shed became the three-end barn.

Horsepower sheds were a rectangular addition to the front of a barn, with cut-off wall corners. Very rare, these sheds were used for a threshing machine powered by a horse and are occasionally found in New York and Pennsylvania.

Decoration

Farmers didn't spend much time decorating their barns. However, the door frames were often a different color than the main barn. While many barns never saw a coat of paint, there were plenty of red barns and white barns. Corner posts might be highlighted with a contrasting color, too.

Occasionally a mural might be painted on the side of a barn. Roofs also represented an opportunity to try out different colors and geometric designs.

Early German barns were often painted with hex signs that were intended merely as decoration. In southeastern Pennsylvania, a folk tradition evolved about the purpose of hex signs being good luck, a means of warding off evil.

Leaving the barn door ajar . . .

Having only touched upon the characteristics of barns, it is time to leave the barn door ajar so that the reader may embark of an individual exploration of these symbols of a simpler life that still serve our society as working barns, historic monuments and dwellings. A scrap of interest can unexpectedly bloom into full fledged research, but the few basic questions you will want answered might include: Type of floor plan? Roof type? Wagon door placement—larger doors, on the side or end, centered or off-center? Foundation visible, not visible, low, full height? Foundation material? Wall material? Date stone? Location? Owners name? Siding, horizontal or vertical? And then you're on your own.

Once you begin thinking about barns, you notice them everywhere. Naturally, the best place to look is out in the country. However, since much of what are now suburbs and cities was at one time part of the rural landscape, there are treasures also to be found in relatively stable old communities. They may masquerade as carriage houses (with people living in them), as storage buildings and occasionally prove well preserved as what they were originally: barns.

Even as many of them have disappeared, we probably have access to more barns than any other country. Much of the rest of the world doesn't need our sturdy well-built barns, for they lack the magnitude of production to require harvest storage, or as in many areas of the former U.S.S.R., the agricultural infrastructure is so poor that there is neither storage nor transportation to take advantage of harvests when they are good.

Huge new barns built of steel and concrete are indicators of a revolution in the storage of grain and the feeding and care of animals. Giant silos dominate the landscape where there used to be cupolas and spires. Highly mechanized industrial or corporate farming is light years away from the hands on involvement of the farmer whose farming was not only a career but also his life. Often better built, better cared for than his house, his barn had modernized dairy equipment long before the farmer thought about indoor plumbing for his house.

For the barn hunter, it is the exploration of lesser highways and byways, enjoyment of the countryside, and awareness of the purposes of a hand-made barn that create a new appreciation of chapters in our history that only farmers have experienced first hand. A week before

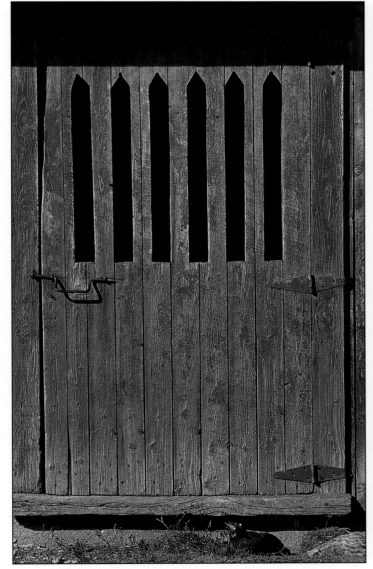

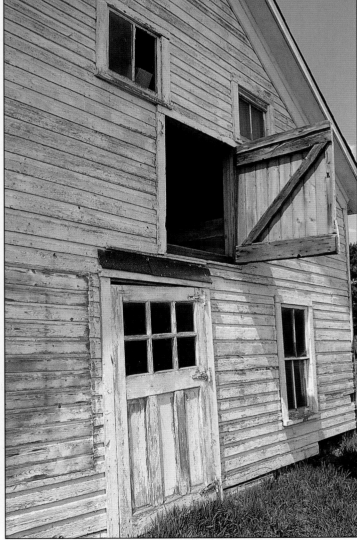

Left: Traditional barn doors in Kamouraska, Quebec, Canada.

Right: This white barn includes several windows, and main doors off the side end, as well as side doors into the hayloft and below.

these final paragraphs were written, I flew to Montana where I inevitably found myself imagining the challenges faced by the courageous settlers who headed west into lands that were far from hospitable. I took the time to observe carefully each barn I passed, looking at the doors, the siding, the roof pitch, and all the elements individually. For 150 miles of a drive from Livingston to Great Falls, I never saw a car in my rear view mirror—not one!—and perhaps half a dozen cars and four lumber trucks in the other direction. The vistas were enormous, wind-swept hay fields, miles of sagebrush, the sky darkening with snow and heavy clouds masking the peaks of the Castle Mountains, making them look really ominous. I would pass a lonely barn, a gable-roofed relic with a hood over the hayloft door, siding falling off, looking as if the wind had punched it hard in the solar plexus, ready to fall in on itself. What stories might it tell? What loneliness did their people know, if on the day I drove by there are still 20 or 30 miles between these derelicts and the closest neighbors. What was life like more than a hundred years ago?

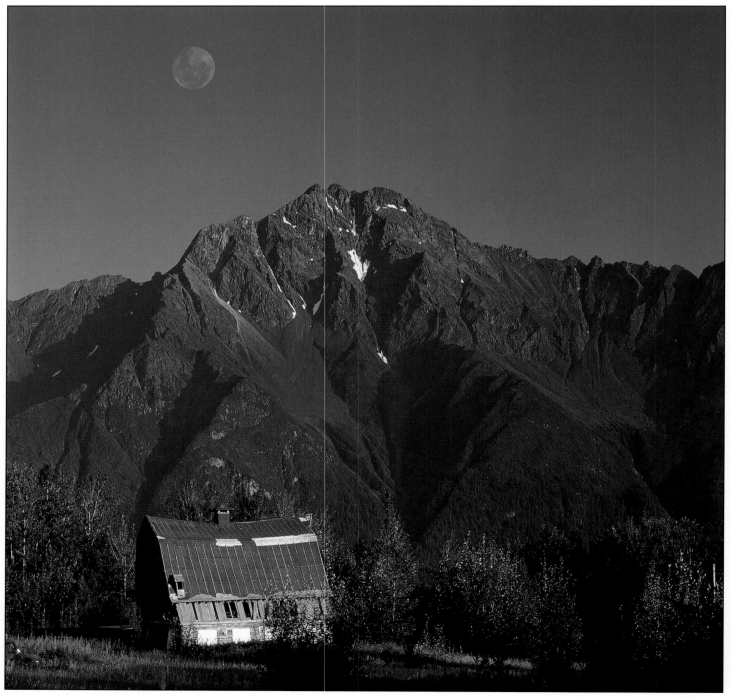

A dilapidated, abandoned barn teeters in front of the majestic façade of Pioneer Peak in Palmer, Alaska.

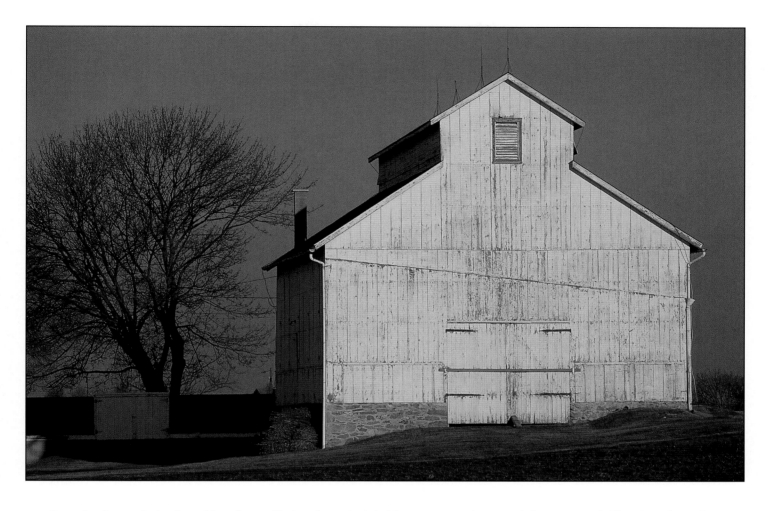

Later in the week, in the midst of a snow storm, my rancher friends, who are second generation on the sprawling Dana Ranch in north central Montana, took me along in a 4-wheel drive pick-up truck to check on the scattered cattle herd. We looked down on the Kitchen place at the bottom of a deep draw, at the tiny weathered house and barn where the dreams of a settlers family died for lack of water.

Today the only inhabitants are cowboys caught in a sudden storm. Returning to the main ranch, the dominant building is a large, one-hundred-year-old barn that serves a variety of uses, dismantled and moved there more than fifty years ago. Within its shelter, machinery is protected from the weather, horses are stabled and calves are born. The cowboys who ride night herd during the calving season

bring young heifers in when they are ready, catch some sleep in an old sheepherder's wagon set up on blocks. A built-in bunk, a little stove for warmth and brewing the incredibly strong coffee, a saddle horse dozing on its feet is a typical scene, even in 2000.

The durable men and women who tied their fortunes to the land don't give up easily. Nor do their barns.

Top: The sunset is reflected off the side of this white barn in Lancaster County, Pennsylvania.

Bottom: Silhouette of a barn at sundown in Brunnerville, Pennsylvania.

"A man's barn bespoke his worth as a man. It expressed his earthly aspirations and symbolized the substance of his legacy to his children."

—Bill Lacy, A.I.A. from *The Barn: A Vanishing Landmark in North America*

Photo Credits

© Accent Alaska/Ken Graham Agency:
 Ken Graham; p. 48 (bottom)
 Gene Jansen; p. 78

© Aiuppy Photographs: front cover detail, back cover, pp. 5 (center), 22, 29, 60, 62, 69

© Barrett & MacKay Photography, Inc.: pp. 3, 5 (top), 10 (bottom), 16, 20, 23, 32, 37, 47 (bottom), 50 (bottom), 70 (top right), 72, 75, 76 (left), 77 (left)

© Corbis:
 David Muench: front cover, pp. 40
 Scott T. Smith; pp. 11
 The Purcell Team; pp. 15
 Darrell Gulin; pp. 19 (top right), 58-59
 Philip Gould; pp. 27 (top), 57 (top)
 Kevin Fleming; pp. 43, 54 (top left)
 Robert Y. Kaufman; pp. 57 (bottom)
 Joseph Sohm; p. 61
 Tom Bean; p.73 (bottom)

© Winston Fraser Photos: pp. 19 (top left), 50, 73 (bottom)

© Jeff Gnass Photography: pp. 6, 8, 12, 31 (bottom), 34-35, 41, 48 (top right), 63, 66, 71, 73 (top)

© Jim Hargan: pp. 27 (bottom), 42 (top right), 42 (top left), 51 (top), 53 (left), 54 (top right), 68

© Grant Heilman Photography, Inc.:
 Grant Heilman; pp. 1, 10 (top), 19 (bottom), 24-25, 28, 31 (top), 42 (bottom), 49 (top), 49 (bottom), 67
 Larry LeFever; pp. 14 (top), 38, 46, 48 (top left), 51 (bottom), 53 (right)
 Fred Habegger; pp. 14 (bottom), 44, 47 (top), 56, 64, 79 (top), 79 (bottom)
 John Colwell; p. 30
 Linda Du Furrena; pp. 33
 Gary Kreyer; pp. 55, 76 (right)
 Peter Marbach; p. 74

© The Image Finders:
 Jim Baron; p. 18
 Carl A. Stimac; p. 52
 T. Williams; p. 77 (right)

© James P. Rowan Photography: pp. 26, 54 (bottom), 70 (top left)

© Kurt Thorson: pp. 5 (bottom), 9, 36